THE GREAT WESTERN COLLECTION

THE GUILD OF RAILWAY ARTISTS

THE GREAT WESTERN COLLECTION

AN EXPLANATION BY

Brian Hollingsworth, M.A., M.I.C.E.

BLANDFORD PRESS

POOLE · DORSET

First published in the U.K. 1985 by Blandford Press,
Link House, West Street, Poole, Dorset, BH15 1LL

Illustrations Copyright © 1985 The Guild of Railway Artists
Text Copyright © 1985 Blandford Press Ltd

British Library Cataloguing in Publication Data

Hollingsworth, J. B.
The Great Western collection: an explanation.
1. Great Western Railway—History
2. Railroads—England—History—Pictorial works
I. Title
385 .0942 HE3020.G8

ISBN 0—7137—1608—8
0—7137—1655—X De Luxe

Colour origination by Colthouse Repro Ltd, Bournemouth, Dorset
Typeset by Keyspools Ltd, Golborne, Lancs.
Printed in Great Britain by Purnell & Sons Ltd.
Paulton, Nr Bristol, Avon
Bound by Dorstel Press Ltd.
Harlow, Essex

CONTENTS

ACKNOWLEDGEMENTS

The Guild of Railway Artists wish to thank the following people for their valuable assistance in the production of this book:

W. H. (Bill) McAlpine – for his help and encouragement.
Richard Erven – for believing in our idea.
Brian Hollingsworth – for being brave enough to write the introduction.
R. J. (Dick) Blenkinsop – for his patience and very fine photography.

and finally . . .

The Member Artists of The Guild who have worked long and laboriously to make sure The Great Western Collection would be a most fitting tribute by The Guild of Railway Artists to the 150th birthday of The Great Western Railway.

DOMINE DIRIGE NOS – VERTUTE ET INDUSTRIA

LORD DIRECT US BY VIRTUE AND INDUSTRY

FOREWORD

The Great Western Railway was in the forefront of many events in our railway history. It is therefore fitting that The Guild of Railway Artists has chosen the Great Western Railway to form its first thematic exhibition, its first touring exhibition, and this, the Guild's first publication.

The Great Western Collection is an exhibition of paintings and drawings by members of The Guild in which they portray, in their own styles, the events in the life of the railway – a tribute to the Great Western Railway's 150th birthday.

And what a tribute! When I saw the Great Western Collection for the first time I was amazed at the variety and skill contained within the works of art. Subjects ranging from Mr Brunel and Queen Victoria to train spotters and porters; from Paddington to Bristol; and from steam to diesel have all been committed to canvas and paper with feeling and enthusiasm.

The initial ideas for The Great Western Collection were presented to the Management Committee of The Guild by Sean Bolan some three years ago and throughout this period Sean acted for the Committee as the Artistic Advisor – without his dedication the Collection could not have been completed. Sean worked in conjunction with Frank Hodges and Stephen Johnson, The Guild's founders and administration team, and between them they have produced what I believe to be a unique exhibition and this, an equally unique publication. Also to be applauded are the publishers for having the foresight to recognise the potential of such a collection – long before any plans were made nationally to celebrate the 150 years of the Great Western Railway.

I for one am proud to have been associated with this magnificent tribute and have no hesitation in now commending to you the efforts of The Guild of Railway Artists in this . . .

THE GREAT WESTERN COLLECTION

The Hon. William McAlpine F.C.I.T.
President of The Guild of Railway Artists
Henley-on-Thames

1 · A GREAT BEGINNING

1835 was the year, and 31 August the day, when the Royal Assent was given – at the second time of asking, for an earlier Bill had failed in the House of Lords the previous year – to the Act of Incorporation of the Great Western Railway Company. It provided for the construction of a railway 114 miles long from 'a certain Field called Temple Mead in the City and County of Bristol' to a junction with the London & Birmingham Railway near Acton. A significant omission from the usual provisions was any mention of the rail gauge, that is, the distance between the rails. So authority was given for the commencement of a great work, one which any reasonable person regards as being one of mankind's greatest achievements.

However, a great deal had to be done before this happy day could be celebrated and one should also take note of a March morning two-and-a-half years earlier, when a young man called Isambard Kingdom Brunel first rode out of Bristol to begin his survey of a route for what was then known as the 'Bristol & London Railroad'. First thoughts were to build the line via Bradford-on-Avon, Devizes and Newbury but very soon a firm choice was made to go via Chippenham, Swindon and the Vale of White Horse, the present route.

Brunel's task was a daunting one. He wrote 'it is harder work than I like. I am rarely much under twenty hours a day at it.' To one who has had a little involvement with such things it is impressive almost to the point of incredulity that his plans were actually deposited with Parliament at the end of November 1833. In April 1834, Brunel was cross-examined on them for eleven days, displaying the greatest patience – a quality which by no means came naturally to him – with the stupidest questioners and charming even his opponents with what one of them described as an 'intellectual treat'.

Others had the less enjoyable task of persuading people to risk their money, notably the Company's secretary, Charles Saunders. He described it as 'sad, harassing work' but his policy of 'gaining more by a quiet process, withdrawing from the observation of our Foes and above all boasting as little as possible of success' prevailed. By February 1835 20,000

£100 shares had been taken up – the equivalent of £400 million in today's pounds – enough to satisfy Parliament.

Incidentally, the most famous of the 'Foes' was Eton College, whose Provost feared for the morals of his charges should this terrible iron road come too close. The GWR allayed their fears by promising not to have a station within 3 miles of the college and also by agreeing to engage extra security staff to keep the schoolboys away from the trains. However, this aloofness lasted less than a month after the first public trains were run, for before that month was out Eton College had chartered a special to take the boys up to London to see Queen Victoria's Coronation.

For some time Brunel had begun to wonder whether, (in his famous words) 'Looking to the speeds which I contemplated would be adopted on railways and the masses to be moved, it seemed to be that the whole machine was too small for the work to be done and that it required that the parts should be more on a scale with the mass and the velocity to be attained.' Before his ideas on the subject became definite he managed to keep his options open by preventing the gauge of the railway being spelt out in the Act.

As it transpired, he soon made a definite proposal and, after considerable argument, the Great Western Board accepted Brunel's recommendation for the adoption of a uniquely wide rail gauge of 7 feet $0\frac{1}{4}$ inch in October 1835. This choice contrasting with the now standard gauge of 4 feet $8\frac{1}{2}$ inches. No one can doubt now that it was a mistake – albeit a magnificent one – but it certainly established the most sacred GWR tradition, that of doing everything, right or wrong, in the GWR's own peculiar way.

An especially important GWR name was first heard towards the end of 1835. The Great Western decided to abandon the original proposal to share the Euston terminus of the London & Birmingham company and in due course one of several further Acts of Parliament approved a line from Acton to 'a certain space of ground adjoining the Basin of the Paddington Canal . . .'. Paddington Station!

On Monday, 4 June 1838 the line was opened to public traffic from a 'temporary' Paddington Station (which was to last 16 years) the site of which was on the west side of Bishop's Bridge Road where the goods station was to be built in later years. The first 'far' terminus was a genuinely temporary station just short of the still unfinished bridge over

the River Thames at Maidenhead. There were no really serious problems in traversing the flattish and then almost totally rural terrain, the only really important structure on this section of the railway being the magnificent Wharncliffe Viaduct at Hanwell. This stands 900 feet long and 65 feet high and, yes, the present tense is still happily appropriate.

All did not go well in those early days. Brunel had not displayed his usual genius either as regards the specification for the early locomotives supplied, or in adopting a system of timber piles to support the longitudinally-timbered track, thereby adding unpleasantly rough riding to unreliable operation. The fact that the rival London–Birmingham line was just as bad in these respects was small comfort.

The track problem was solved simply by not using the piles and disconnecting those already driven, but the locomotive difficulties had to wait until Daniel Gooch, the 24-year-old locomotive superintendent had designed and supervised the building of a remarkable range of six-wheeled standard locomotives. There were to be 62 locomotives of the 2-2-2 wheel arrangement with 7 foot diameter driving wheels (the 'Fire Fly' class); 21 2-2-2s with 6 foot wheels (the 'Sun' class); 18 2-4-0s (the 'Leo' class) and 4 0-6-0s of the 'Hercules' class. No further motive power was to be needed until 1846.

Previous locomotive imperfections were avoided by insisting that the manufacturers should follow exactly precise specifications. Full sets of drawings – over which two famous men, Daniel Gooch and Thomas Russell Crampton, burnt much midnight oil – as well as templates were supplied with each order. Furthermore, the builders were to be held 'liable for any breakages that may occur, either from bad materials or bad workmanship, until each engine has performed a distance of 1,000 miles with proper loads'. This particular clause was included in all subsequent contracts for the supply of locomotives as long as the GWR existed.

The first of these lovely little fire chariots to be delivered was *Fire Fly* herself. She arrived in March 1840 and indicated the shape of things to come by reaching a speed of 56 m.p.h. on her first trip. By the time the line was opened to Swindon in December, 23 further engines were on the property. They carried their names spelt out in brass letters in the same exaggeratedly Roman style and centred on the driving wheels, just as almost all named GWR locomotives were to do for more than a century to come.

It was fortunate that satisfactory motive power was flowing in at a fast pace, for soon enough the great day came – it was 30 June 1841 – when Bristol and London became linked by rail and the Company's principal objective achieved. For some reason which remains unknown there seems to have been little or no ceremony to mark the occasion – the trains just began running. Yet the day marked the end of a first brief age of glory in the building of railways. It was a period when the railway had to be a thing of beauty, worthy both of its high objectives and its setting in lovely unspoilt countryside, which in those far-off days was still Shakespeare's 'precious jewel, set in the silver sea'.

Following this early railway construction the structures to be provided on future stretches of line became purely economic and utilitarian, rather than part of a grand design. Engineering bricks replaced Bath stone; and elsewhere naked timbers or ironwork affronted the eye instead of elegant arches to enchant it.

The grand celebration of the Bristol to London route came two years later when the next stretch of associated railway was completed between Bristol and Exeter, making possible what was by far the longest railway journey in Britain. The GWR worked the line, which had been built by the independent Bristol & Exeter company, for the first five years. On the great day, 1 May 1844, a special train took guests down from London for a banquet in the Exeter Goods Shed. Daniel Gooch drove personally both ways and coming back in the evening the 194 miles were covered in an amazing 4 hours 40 minutes, including no doubt numerous stops for water and possibly coke, too. Gooch's diary records the locomotive as 'Fire Fly' 2-2-2 *Actaeon* but other records indicate it may have been *Orion* of the same class. Or perhaps they changed engines halfway and used both of them.

This was not the earliest notable run to be made by these engines. *Phlegethon* (both Gooch and Brunel were on the footplate) had delighted the young Queen Victoria with her first train ride, from Slough to Paddington on 13 June 1842. In 1843 Gooch brought Prince Albert – who had gone Great Western to do his courting as early as 1840 – back from launching Brunel's famous steamship *Great Britain* at Bristol, covering the 119 miles in 160 minutes.

Although it was not to last, for the GWR and for the broad gauge it was a golden age. In

spite of huge over-spending on the building of the line, traffic was buoyant and profitable enough to pay a delicious 8% dividend to the shareholders. Both the railway and its equipment were now excellent, enabling the GWR to run spacious and comfortable trains that were easily the fastest and best in the world. 222 miles of railway was an excellent size to administer; each of the department chiefs could know all his men by name.

The locomotives were also known only by their names; none were insulted by having numbers, not even goods engines. They were almost all of one standard basic design, a GWR tradition that was to be forgotten with dire results and then re-introduced to excellent effect over the years to come. Lastly, the Company had in Charles Saunders a chief executive officer who insisted on (and was notorious for practising himself) the greatest GWR tradition of them all – namely, unfailing courtesy to customers even in the most trying circumstances.

2 · GREAT TROUBLES

Presumption often gets its just desserts and the fate of the one challenger to what Brunel sometimes called contemptuously 'the coal waggon (sic) gauge' was no exception. The broad and narrow gauges (7 feet 0¼ inch and 4 feet 8½ inches) had met at Gloucester in 1844 and the difficulties which arose there over the interchange of traffic led to the appointment of a Royal Commission. The Gauge Commissioners – the Astronomer Royal, Professor Airey, was one of them! – presided over comparative trials. Although the Great Western 2-2-2 *Ixion* covered itself with glory by demonstrating superiority as regards rather irrelevant matters such as performance and coke consumption, the commissioners inevitably recommended in 1846 'that the Gauge of 4 feet 8½ inches be declared by the Legislature to be the Gauge to be used in all public railways...'. The result was the Gauge Act of 1846, which did at least exempt lines in GWR territory from its compulsion to adopt what was now the new standard gauge.

But it was also inevitable that the day would soon come when the GWR would have to demean itself with the lesser size. It was in 1847 that three miles of GWR mixed gauge railway – that is, with combined narrow- and broad-gauge, i.e. three-rail lines – was opened between Gloucester and Cheltenham. Then 66 miles of broad-gauge route between Oxford and Birmingham were made mixed gauge in 1852 and in 1854 the first solely standard gauge line – between Birmingham and Chester – was acquired.

Worse was to come. In 1861 the mixed gauge entered the sacred precincts of Paddington and soon afterwards conversion of broad gauge and mixed gauge lines to standard gauge began apace. In fact, the mileage of GWR standard gauge first exceeded that of broad gauge as early as 1869. There was also much more mixed gauge, to an extent that six years later, 40 years after the broad gauge was born, the total of purely broad-gauge GWR line had shrunk to a mere eight miles, consisting of the short Henley-on-Thames and Faringdon branches. All that was left were the routes of the South Devon Railway and the Cornwall Railway, both almost wholly broad gauge and to become amalgamated with the GWR in 1876. Through trains to these lines ran over mixed gauge rails retained

for them along the original main line from Paddington to Exeter.

The burden of running two incompatible railway systems simultaneously must have had its effect. But it was as nothing compared to a smash-and-grab expansionist policy which increased the mileage by five-and-a-half times in the 20 years from 1845 to 1865, but drove dividends down from that magnificent 8% in 1845 to an average of less than 2% in the 1860s. Two final extremities of the GWR system were soon reached; Weymouth in 1857 and Birkenhead in 1860. The South Wales Railway serving Cardiff, Swansea, Carmarthen and Neyland was acquired in 1862. A huge lump of in-fill came with the West Midland Railway in 1863 and this included the notorious Oxford, Worcester & Wolverhampton Railway — the 'Old Worse & Worse' — whose *de facto* defection from the broad gauge camp did such terrible harm to the Cause. Plymouth and Penzance, however, had to wait to come into the fold until the great amalgamation of 1876. After this event the GWR became the longest railway in Britain by several hundred miles, but it was not a matter for congratulation.

Sixty years later, having reached calmer waters and regained all and more of its erstwhile prestige, the GWR commissioned a distinguished historian, Mr E. T. MacDermot, MA, to write its history, which he did brilliantly in two unputdownable volumes, originally produced in three parts. The sub-headings of the chapters dealing with the complex but stirring events of those days include such items as … 'A GREAT BATTLE — CAPTURE BY THE ENEMY — ANOTHER FORGED SEAL — STORMY MEETINGS — THE CHAIRMAN'S NIGHTCAP — SECOND BATTLE OF WOLVERHAMPTON — A TREATY — ENEMY SPITEFUL TO THE LAST …'. They make entertaining and exciting reading, quite untypical of multi-volume company histories!

It was a long haul out of the mire and success was only achieved by strict economies. A notable one was to run the trains more slowly; for example, the legendary *Flying Dutchman* which as early as 1845 reached Exeter in 4 hours 30 minutes, was taking 5 hours 5 minutes 22 years later. Less prestigious trains fared even less well. But in the 1870s matters improved; the company even ventured into new construction and one notes the opening in 1877 of the last new broad gauge line, the St Ives branch, as well as a slow start being made on the most ambitious project of all, a tunnel under the River Severn.

Even with the company's finances in better shape, there was a great deal else to put in order. Many of the new lines had been cheaply and hastily constructed; tracks needed relaying with heavier materials, timber bridges needed replacement with more durable ones. The interlocking of points and signals was required and the continuous vacuum brake had to be applied to all coaching stock.

There was also one other change to be accomplished before a new age of glory could begin and it was a very sad and final one. The grand old broad gauge had, at last, to go. As has so often been described, the execution was done with great panache in May 1892, when 42 miles of double and 129 miles of single broad-gauge line in Devon and Cornwall was successfully converted to standard gauge in a single melancholy week-end.

The work was done by 3,400 experienced permanent way men brought in by special trains from all parts of the system. They were divided into gangs of about 20 each with approximately a mile of track to convert. All possible preparation was done beforehand and with such ample resources deployed this author (who spent many years in this particular world) considers that the apparently near-impossible task was in fact a very easy one. The GWR's Engineering Department staff habitually accomplished many much trickier but unsung tasks in the course of their normal day's work. But, fortified with the traditional gauge-conversion drink of oatmeal gruel provided by the company, on that mercifully fine and warm week-end, they closed for ever a whole book of railway history.

3 · AGAIN GREAT

By the 1880s the Great Western Railway had fallen so low it was great only in size. In most other ways it had descended from being unquestionably the best in the world to what could only charitably be described as mediocre. But in 1886 the opening of the Severn Tunnel, then as now, the longest main-line railway tunnel in Britain, raised the curtain on a massive programme of improvements which took the GWR once more to its old position at the head of Britain's railway companies. New trains, new timetables, new motive power and new routes were to come in quick succession. Even the broad gauge awoke for a moment in 1890 from its terminal coma, when the new *Cornishman* express was introduced. This train at last overtook the *Flying Dutchman* of forty-five years earlier, by running to Exeter in 4 hours 5 minutes – and accommodated third class passengers while doing it, too.

Britain's first corridor train went into service on the GWR in 1892, restaurant cars first appeared in 1896 and in 1900 electric light was first applied to a GWR train. All three rapidly became standard features of the company's express trains. So not only were the new trains heavier, they were also faster, too, and to pull them the power and size of locomotives had to be very much greater. Such small but elegant machines as the 'Achilles' class 4-2-2s of 1892, old-fashioned even for the day, had to give place to the comparatively huge 'Star' and 'Saint' class 4-6-0s of 1906, which were far ahead of their time. The change involved increases of almost 100% in tractive effort, 35% in grate area, but only at a penalty of an increase of some 50% in weight.

Haphazard development of the GWR system had led to the emergence of roundabout routes – the Great Way Round they were called – but soon enough the Severn Tunnel had lopped 15 miles off journeys from Paddington to South Wales. Then in 1903 the new 30-mile South Wales & Bristol Direct Line between Wootton Bassett and Patchway took another 10 miles off the trip. With faster running it was possible to cut one-and-a-half hours from the journey time between Paddington and South Wales destinations compared with pre-tunnel days!

Other cut-off lines reduced distances and journey times by lesser amounts, notably between Paddington and Exeter, and from Birmingham to Bristol and South Wales. Between Birmingham and London the new line from Aynho Junction near Banbury to Old Oak Common took 25 minutes off the best timings and made the GWR competitive at last with the London & North Western Railway.

All these schemes paid off handsomely, except for one which was a disaster. The GWR Board must have felt some disappointment that although they 'owned' the whole of the south-western seaboard, none of the great ocean shipping lines used their facilities. So the idea was born of turning the little West Wales harbour of Fishguard into a great passenger port and to this end vast expenditure was incurred. Enormous sums went into quays and a terminus which was built at a site where before the railway came cliffs fell perpendicularly into the sea. There was also miles of new double-track main line railway on the approaches and even three new turbine steamships. Added to this there was further substantial investment in new railways and a harbour in Ireland.

Fishguard was 130 miles nearer New York than Liverpool and on 25 August 1910 the legendary four-funnelled ocean greyhound RMS *Mauretania* called for the first time. It is said that the decision of her master not to take her in was made at the last minute, but passengers and mail were brought ashore by tender. Even so the great Cunarders continued to call once or twice a week on their way to or from Liverpool and several Ocean Liner specials – for which special carriages known as 'Cunard Firsts' were built – were run on each occasion. Train formation lists of forty years later still referred to 'Cunard Firsts' in their pages; they were unusual because most GWR first-class accommodation was in composite carriages.

Thus encourged, the Board put in hand a 15-mile by-pass, known as the Swansea District Lines, so that boat trains could avoid a time-consuming reversal at Swansea High St Station, but the link was not finished until the First World War had begun. Then soon after it was over, the great liners moved to Southampton, whilst traffic to and from Ireland slumped on the country attaining its independence, thereby removing most of the justification for the work done.

The happy event of the post-war period was that the GWR came through the trauma

of the railway grouping of 1923 with its name and honour intact. Perhaps the fact that the GWR was by far the largest pre-grouping railway and was also geographically speaking reasonably compact, had something to do with this merciful with-holding of irresponsible political meddling. But whatever it was we must be thankful that so little changed, for another of the great periods of the GWR lay ahead.

With the entry of the little Cambrian Railway into the fold, once again the GWR became a multi-gauge railway, with two (later three) new narrow gauges to compensate for the small non-standard mileage. Once again also, GWR carriages appeared in traditional chocolate and cream livery and once again GWR locomotives were handsomely lined out, as well as being handsomely decorated with polished brass and copper.

They also showed themselves to be more than pretty faces when *Pendennis Castle* and *Launceston Castle* demonstrated a substantial degree of superiority over the native products, when tried out on the new LNER and LMS railways in 1925 and 1926 respectively. Action speaks louder than words and while the LNER was content to alter their locomotives with gratifying results, the LMS actually engaged William Stanier, second-in-command at Swindon, to take charge of the design and building of a new locomotive fleet.

The 'Castle' class were stretched 'Stars', but they introduced a new principle that locomotives of the same class should all bear related names. It was a sensible idea but maybe just a trifle dull. The 'Kings' of 1927 claimed (on slightly doubtful grounds) the title of the most powerful locomotive class in Britain and the GWR's excellent publicity department — about whose abilities and drive there was absolutely no doubt — did wonders with it.

They also did wonders with a lightweight afternoon train which drifted leisurely, stopping often, from Cheltenham to Swindon at an average speed (based on distance as the crow flies) of a scarcely believable 22 miles an hour. The same train then made a dash along Brunel's superb original main line to Paddington, at a start-to-stop speed that — off and on throughout this period — was faster than any other booked passenger train the world over. This was the legendary *Cheltenham Flyer*, more prosaically described in the timetable as 'CHELTENHAM SPA EXPRESS — TEA CAR TRAIN'. As the years went by, the timings

for the 77-mile run were progressively reduced so as to keep ahead of the opposition, to culminate in one of 65 minutes, giving an average speed of 71 m.p.h. It was also done on occasion in much less, notably on 6 June 1932 when a time of just under 57 minutes was achieved.

Another notable achievement of the Publicity Department was their literature. A good part of the reason for the GWR being the first and best love of so many enthusiasts was because most of the few available books on railways in those pre-war days were published by the GWR.

There were eight of them called successively *Ten-Thirty Limited, Caerphilly Castle, Brunel and After, The King of Railway Locomotives, Cheltenham Flyer, Track Topics, 'Twixt Rail and Sea, Locos of the Royal Road* as well as the very first 'spotter's' book, *GWR Engines — Names, Numbers, Types and Classes*, which ran to many editions. But now that all we have are memories, we find (to take a single publisher as an example) Oxford Railway Publishing Company with 40 GWR titles to its credit and over twenty in its current list!

Perhaps the centenary year of 1935 was the GWR zenith, new trains were introduced, a programme of major station improvements had just been completed and GWR Ordinary shares whilst nothing to boast about, at least stood at several times the average of those of the LMS and LNER. The end was near, though, because although the GWR did great things in World War II, in order to achieve them, standards had to be dropped to a point where they were hardly Great Western. And once it was over plans to put things right were soon overlaid by political meddling on a scale even more massive than that which had gone before. This time the company was unable to fend off its enemies and so it was that on 31 December 1947 our beloved Great Western ceased finally to exist as an independent entity.

4 · GREAT LINES

It would have been fun as well as hard work helping Brunel to survey and set out the line of the first and original Great Western route in 1833. Having begun this chapter by mentioning those who surveyed the first GWR line, I wondered whether perhaps those who set out the last one enjoyed what they did. Would it have been for the Frome and Westbury cut-off lines in the 1930s or perhaps for some war-time project? Then suddenly it was a great thrill to realise that I knew well when it was. It was in 1947 (just before the World came to an end!) and we were setting out a new diversion line round the giant, and then unbuilt steelworks at Port Talbot in South Wales. And, yes, thank you very much, it was very enjoyable as well as an honour. There was pay, too!

Brunel is said to have been excellent company and a famous story is told of his little band putting up for the night at an inn in the Vale of White Horse, after a day of being harassed by landowners and their minions. The idea of getting a bit of their own back by changing the actual White Horse on the Downs above into a locomotive came into the conversation. Brunel instantly drew out his pocket book and worked out a scheme with so many men needed to strip the turf from so many square yards of chalk between dusk and dawn; happily, though the idea remained a project. But he did leave behind one sign and that is one which will keep his legend alive for ever. For the bore of Box Tunnel was set out so that the combination of its direction and inclination is such that the rising sun shone through the bore on its engineer's birthday, 9 April. Of course IKB was a superb mathematician and he would have had no difficulty with the calculation involved.

As one might expect this particular calculation is not one of the many preserved for us at Bristol University in Brunel's General Calculation Book; in which can be found the mathematics involved in his structures large and small. It is a great pleasure to record that apart from those built from timber nearly all the great structures of the original London to Bristol line still stand carrying today's much faster and heavier trains.

Brunel concerned himself with the minutest detail of what is still very much his railway. In addition there are his sketch books (which have also come down to us) and

they include delightful little oddments such as designs for lamp-posts alternating with, say, Paddington Station's track layout. So began the noble tradition of everything Great Western being made the Great Western way. Naturally this began with the original permanent way, which was fundamentally different from any other, being laid on longitudinal timbers to the widest gauge ever used for a railway system.

This difference remained even when it became one of detail rather than of principle. One of the finest books on railways is the little known *British Permanent Way* published by the Permanent Way Institution and now in its fifth edition. In earlier editions there was one recurring phrase and it was 'except on the Great Western Railway'. Even the language is different – for example, the true GW man does not speak of such things (similar on other lines) as points and crossings, obtuse crossings and single or double slips; but instead of fittings, elbows and single or double compounds.

Even though GWR track was not so totally different latterly as it was in the days of Brunel, when it was laid with bridge rails, it was still rather different. Twentieth-century GWR track was bolted rather than screwed to the sleepers, an arrangement that had its drawbacks but which (as this writer found out the hard way) in the limit did its job better by holding the track to gauge more reliably. It perhaps says enough that when British Standard permanent way was introduced in the 1920s, based on the BS.95 rail weighing 95 pounds to the yard, for most railways in Britain this represented progress towards heavier and stronger track. Not so for the GWR which had to come down from its own heavier '00' rail section weighing $97\frac{1}{2}$ pounds/yard (pronounced 'ought-ought', please, not 'oh-oh') to take in the new standard.

Three little-known but quite charming oddities of GWR permanent way practices are worth mentioning. The first was that all but the simplest junction layouts were tailor-made for the site, instead of being made up from standard track components, as was done elsewhere. This made it necessary when something broke to ring 'X' shop at Swindon, who prided themselves on giving instant service by manufacturing a spare there and then.

The second oddity was that there was no general speed limit and in theory unlimited speed was permitted wherever no specific limit was promulgated. This neat piece of

Oneupmanship on the part of the Chief Engineer over his colleague the Chief Mechanical Engineer was harmless because even down an incline steam locos are liable to choke themselves before speeds reach untried levels. Incidentally, only journalists used the rough north-country term 'bank' for GWR hills, so it was as 'Dainton Incline' rather than 'Dainton Bank' that the steepest main-line gradient in Britain should be correctly referred to. And finally, if one made a drawing – even a sketch – in the CE's office, the first rule to learn was 'Paddington on the right'!

The fact that the man in charge of GWR civil engineering claimed the title of Chief Engineer (from the days when Brunel was in command of all engineering) made of itself no contribution to what had to be his first preoccupation, that is, the safe running of trains. But there was one important difference which did. The Chief Engineer on the GWR was one whole administrative level closer to the man on the ground than the Chief Engineers on (for example) the LNER or Southern lines and two closer in the case of the LMS.

The GWR scored a first with another sort of line. As early as 1839 a telegraph line was in use alongside the railway; by 1843 it had reached Slough and become a fairly reliable means of communication. An early message resulted in a murderer who was escaping by train to London being arrested as he stepped off the train at Paddington. In 1847 the telegraph was first used to signal trains, through Box Tunnel. But it must be said that the GWR was rather slow in extending its use elsewhere, but the company retrieved their honour when their first Telegraph Superintendent, C. E. Spagnoletti, patented the single-needle block telegraph instrument, which made a fundamental improvement to the safety of rail travel.

The original GWR signals were very distinctive with spectacular disc-and-crossbar stop signals and strange 'fan-tail' distant or warning signals. Even in later years, after the other British railway companies had standardised on semaphore signals that were raised from the horizontal for 'all-clear', the GWR's semaphores pointed downwards for 'go' and at a particularly sharp angle of drop.

Such things as whether signals went up or down were fairly superficial, but later GWR signalling had one feature which raised its effectiveness as a safety measure into a different

league compared to that of other lines. This was the Automatic Train Control system, introduced in 1906. The aspects of distant signals were repeated in the locomotive cab; a bell rang for 'all-clear' and the brakes were automatically applied if the signal was 'on'. By 1938 ATC (now called 'AWS', standing for Automatic Warning System) was applied system-wide on the GWR whereas the other railway companies had still to proceed beyond pilot installations. The drivers called it 'our little friend in the corner'.

This system was used not only to ensure obedience to signals but also to cover temporary restrictions of speed, necessary when lines are being repaired. On the GWR it was the rule to supplement lineside warning boards by disconnecting the distant signal in the rear, so that drivers got both a visual and an audible signal as well as an automatic brake application. This was a further contribution to the GWR's enviable safety record, which was in no way a matter of luck.

5 · GREAT TRAINS

Except over short distances and for fun it is sadly no longer possible to travel in the great trains of the Great Western Railway. Of course, in writing of their excellence this author is anything but unprejudiced because in his formative youth journeys in them were high-spots, simply included in every one of his years between the ages of two and twenty-four.

If by some magic one could go back just once for another helping, a reasonable choice would be to ride the prestigious *Cornish Riviera Express* of between 50 and 60 years ago. As it might stand ready to depart from No. 1 Platform at Paddington Station, there should be a brand new 'King' class 4-6-0 at the head of fourteen coaches and all except one would be 'seventy-footers', i.e. 73 feet 6 inches over the buffers. Today's 'Riviera' has only eight coaches of similar weight, size and capacity but needs two locomotives to move it!

Passengers were spared a good deal of trauma because destinations at the end of eight different branch lines could be reached without changing carriages. Delays in detaching each portion of the train from others were kept within bounds because those for non-Cornish destinations (Weymouth, Ilfracombe and Minehead, Kingsbridge) were slipped while passing Westbury, Taunton and Exeter at speed. The main train would run the 226 miles from London to Plymouth non-stop.

Slip coaches were a GWR speciality and in the 1920s more than 50 were detached daily, compared to a tenth of that figure for the rest of Britain. Special coaches with special slip couplings, special brake systems, special multiple tail lamps and in charge of a specially-trained Slip Guard, were detached on the move and at speed from the rear of fast express trains under the control of special 'slipping distant' signals and the guidance of reams of special instructions.

Before going to see the glorious piece of highly polished machinery at the head end of this best of GWR express trains, one should not forget the humble 0-6-0T 'pannier' tank engine that brought the empty carriages into the station. The rest of Britain never really made up its mind whether a tank loco should have its tanks alongside the boiler where they made the mechanism inaccessible or on top (known as a 'saddle tank') which made

it difficult to get at important fittings which then had to be sited underneath. The GWR neatly solved the problem by yet another of its excellent specialities, that is, by hanging the tanks along the side of the boiler and smokebox in the form of panniers.

An invisible GWR speciality was accuracy of construction. Swindon believed that it was cheaper in the long run to build engines with a greater degree of precision than was the practice elsewhere in the industry and in the 1920s they got themselves **the** kit which included sophisticated Zeiss optical lining-up and measuring apparatus. Others continued with centre pops and scribed lines, and when British Railways issued nationwide schedules of fits and limits, it was found that the standards for 'new' on BR differed little from GWR ones for 'worn out'.

So the beauty of the 'King' up front on this train was much more than skin deep. And it would be a sight to remember with polished brass, and copper and steel setting off shining Brunswick green paintwork lined out in black and orange. The outside motion connecting the two outside cylinders to the wheels would have looked nice and simple, but between the frames could be seen a more complex and more inaccessible mechanism. There was not only the corresponding connection between the inside cylinders and a crank axle but also the Walschaert valve gear. It was an odd arrangement and was shared with both the 'Castles' and the 'Stars'. But this author feels all three classes were satisfactory in spite of rather than because of it, for the steam locomotive's strongest card is its simplicity and this should not be thrown away.

One would not have to look very far to find something better; at an adjacent platform there might have been a two-cylinder 'Saint' on the 10.45 to Cheltenham or more certainly a '61xx' 2-6-2T on a suburban train. Stephenson link motion between the frames timed the valves of the two outside cylinders via rocking shafts; it was a simple mechanism shared by some 1,500 GWR locomotives and so had all the qualities implicit in continuous detail improvement over many years.

But all the bigger GWR engines shared the same excellent and unique basic design of boiler. This was of tapered domeless pattern with Belpaire firebox, top feed and a plain (i.e. non 'pop') safety valve enclosed in the famous 'coffee pot' cover situated half way between chimney and cab.

The GWR diesel railcars, which developed into British Rail's huge fleet of diesel multiple-units, had not appeared by the end of the 1920s – and rarely reached Paddington when they did arrive. Electrification was not a GWR forte and the company was rather ashamed of their nice electric trains which popped out of the underground into Paddington Station and then proceeded to Hammersmith. In fact the GWR owned outright half the trains on this line although they were all lettered 'METROPOLITAN & GREAT WESTERN'. The ganger in charge of the track at Paddington used to express *his* contempt for electric traction (and impress this author) by putting his horny palm on to the conductor rail to see if the current had been switched off!

The top brass did the same thing by other methods; when they were forced to look into electrification in the late 1930s they chose for the guinea pig an area of their system – the main lines west of Taunton – which on the face of it seemed a likely candidate, but in fact had hidden features which made the idea almost bound to fail. The reality was that the required number of train-miles to justify the capital expenditure were actually concentrated in a few summer Saturdays. One strongly suspects that an examination of Paddington to Bristol and Cardiff routes would have produced a reasonable case. But an interesting point about the Consultants' report was that they just did not believe the GWR's costs for building new steam locomotives – Swindon could build a 'Castle' for £5,800 in those days – and assumed there had been a mistake.

6 · A GREAT FUTURE

Of the four large railway companies that were abolished in 1947 to form British Railways, only the GWR had had a corporate life longer than 25 years. But since the GWR was in so many ways the one that was out of step with the others it was the GWR that had to change. This was hard for a loyal staff who had been taught all their working lives that GWR ways were the best. Moreover, the doctrine had often been with them from birth because their fathers, grandfathers and even great-grandfathers had been there before them. And even with hindsight most former GWR employees still alive feel this way to this day. There was a slight comfort, though, in that when BR announced some world-shattering innovation, many GWR men felt BR could hardly go wrong in doing what the GWR had been doing 40 years (or whatever) before.

The most tragic of these matters culminated in the notorious accident at Harrow in which 113 people died, following which BR (after a long delay spent in completing the re-invention of the wheel) put a cab signalling system on its non-GWR lines. But Slough (the geographical equivalent of Harrow on the GWR) had had one since 1906!

In the part of the forest inhabited by people such as your author, the big difference lay in what under the new regime constituted good house-keeping. If a bridge, say, began to show a need for repairs, one was taught to make an estimate and submit it to the Civil Engineering committee of the GWR Board for approval. They met every month (except at the start of the shooting season!) so authority to proceed was soon granted and one could get on with the job on the basis of 'a stitch in time saves nine'. Under BR it was a case of several successive annual submissions with the best engineer being the one best at the paper work.

But no good comes from living in the past and most of us accepted what had happened. We even became fairly good at the complex and arcane (but demonstrably and with hindsight quite useless) financial calculations insisted upon by the accountants.

Occasionally someone of influence tried to set the clock back. Of course, we all stood up and cheered when Reggie Hanks, the General Manager at Paddington, tried to set the

tone by sending out an instruction that 'no locomotive other than one of ex-GWR design shall be rostered to work any train on which I am due to travel', but it was really an unprofitable thing to do. Much better for Swindon to test a 'Dean Goods' 0-6-0 of the 1880s in a scientific manner, demonstrate a considerable superiority over its BR replacement and then alter the latter so that its many virtues could be used to advantage. This actually happened!

As we have seen there were still the books on the old days and of course there were models, too. There were also a few GWR artifacts stuffed and mounted in museums or on station platforms. But for live preservation we must thank the brave souls who took their courage in both hands, closed their ears to those who said it was impossible and as amateurs took over in 1951 the running of the 2 foot 3 inch gauge Talyllyn Railway in North Wales. The line's two locomotives were badly in need of a rebuild but happily the ex-GWR part of BR stepped into the breach with two others (ex-GWR as regards ownership but not as regards design) of the same gauge from the nearby Corris Railway, recently closed. In this indirect way the preservation of GWR machinery for active use began, even if it was truly narrow gauge.

Full-size active GWR preservation had to wait 10 years for this seed to germinate. It was initiated, oddly enough, not by the older generation of GWR lovers who knew the line in its great days before 1939, but by the schoolboy train spotters of Southall, Middlesex. They lived only a short distance from the place where construction had begun some 130 years earlier. There was severe discouragement and even harassment from non-GWR people now in charge at Paddington, put in with instructions to 'de-Westernize' the Western, but the boys persevered.

They began by founding the Great Western Society and acquiring a small '48xx' class 0-4-2 tank engine. Then, displaying *savoir faire*, grit and persistence well beyond their years, they battled for eight years to bring into use a working museum-depot in the London area. In the end 10 May 1969 was the day when the first steam open day was held at the Society's depot at Didcot. Now there is suitable motive power available at Didcot to cover every GWR haulage task from heading the *Limited* to doing a humble shunt in the docks; as well as making up several complete trains.

The active preservation of Great Western lines began when the six mile long Dart Valley Railway at Buckfastleigh in Devon received its Light Railway Order on 1 April the same year. Since then others have followed, there now being 10 lines with some 75 miles of route, although few of them work many trains with ex-GWR engines and rolling stock. An exception is the Severn Valley Railway, which runs south from Bridgnorth, Shropshire. This remarkable company recently raised, without difficulty and without offering any prospect of financial return, £300,000 to build an extension to Kidderminster, including an elaborate new traditional GWR terminal station. Preservation has come a long way since the Talyllyn Railway Society had to dig deep into their coffers to find £50 to buy GWR Nos. 3 and 4 in 1951.

Great Western express locomotives are also allowed out to run on British Railways, notably between Didcot and Tyseley (convenient for the Birmingham Railway Museum) and between Newport in South Wales via Hereford to Chester. After normal steam running ceased on BR in 1968, preserved steam engines were also generally prohibited. This ban remained until 1971 when *King George V*, no less, made a system-wide tour under the auspices of Bulmers, the cider makers of Hereford. Since then this activity has become regular. For a time both the Great Western Society and the Severn Valley Railway fielded complete vintage GWR trains on these steam-lovers' specials.

There is now virtually no significant twentieth-century class of GWR locomotive which is not represented by at least a close relation amongst the 125 or so preserved GWR steam locomotives in Britain, but when it comes to the nineteenth century the opposite is true, 'Dean Goods' 0-6-0 No. 2516 of 1887 rests in the GW Museum at Swindon, but otherwise (apart from some oddments not of GW origin) there is only that replica of *North Star*, the first locomotive to run on the GWR. So the broad gauge, a whole unique and different concept of railroading, came and went with nothing significant remaining to show for it.

Happily, the 150th anniversary of the incorporation of the company has been taken as an opportunity to redress the situation. As regards locomotives, replicas of one of the 'Fire Fly' class 2-2-2s and of the 4-2-2 *Lord of the Isles* of the 'Iron Duke' class have been constructed. Regarding other facets of early GWR practice, the GW Society has already

installed a broad gauge track layout at Didcot and Brunel's fine train shed and buildings at Bristol have been restored.

All this is made possible because people enjoy old trains, particularly if they are GWR ones. So in a totally unexpected way a new era of greatness for the grand old GWR has begun, but this time it is showbiz not transport. And it is wonderful to record that the Great Western has just as great a degree of pre-eminence in this new field as ever it had in the past. May it stay this way for a long, long time.

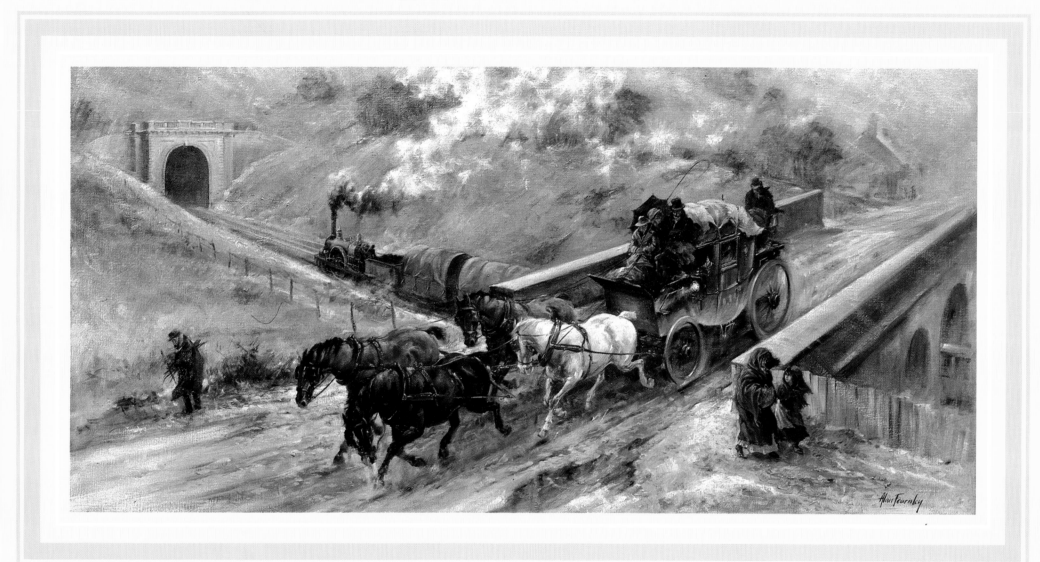

1 POST COACH – BOX TUNNEL · A.FEARNLEY GRA

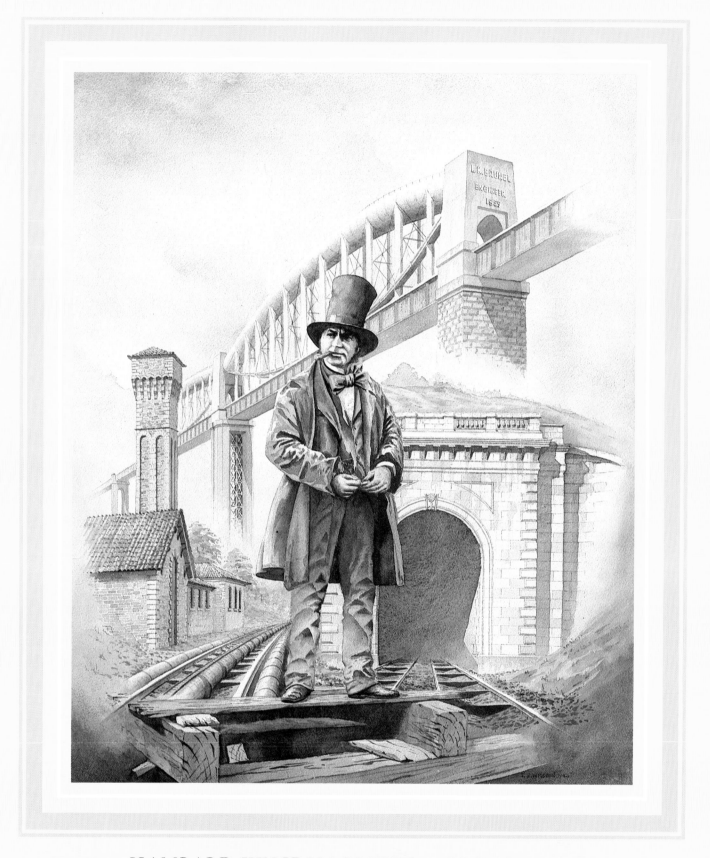

2 *ISAMBARD KINGDOM BRUNEL · J.E.WIGSTON* GRA

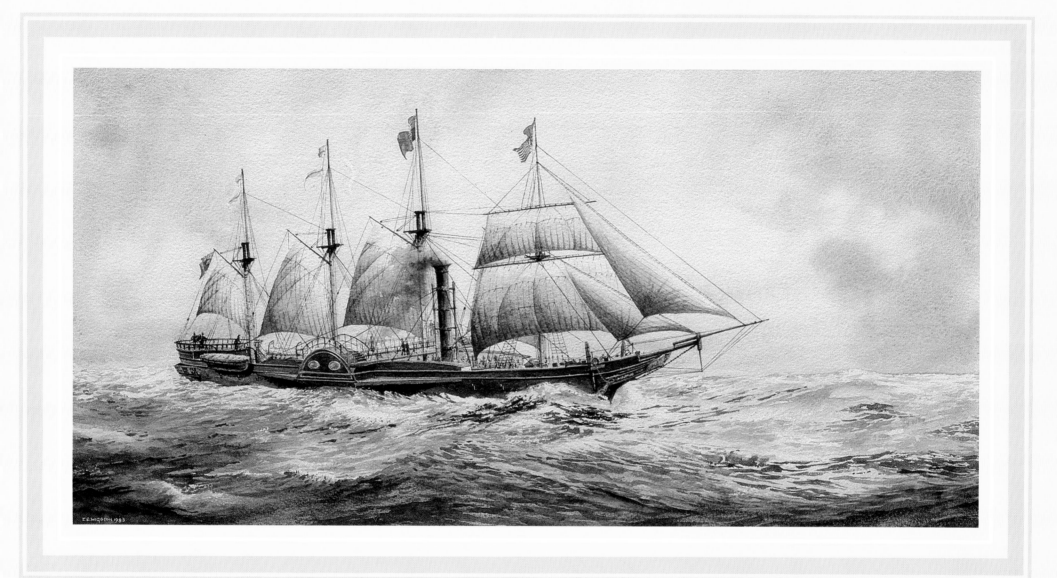

3 'THE GREAT WESTERN' PADDLE STEAMER · *J.E.WIGSTON* GRA

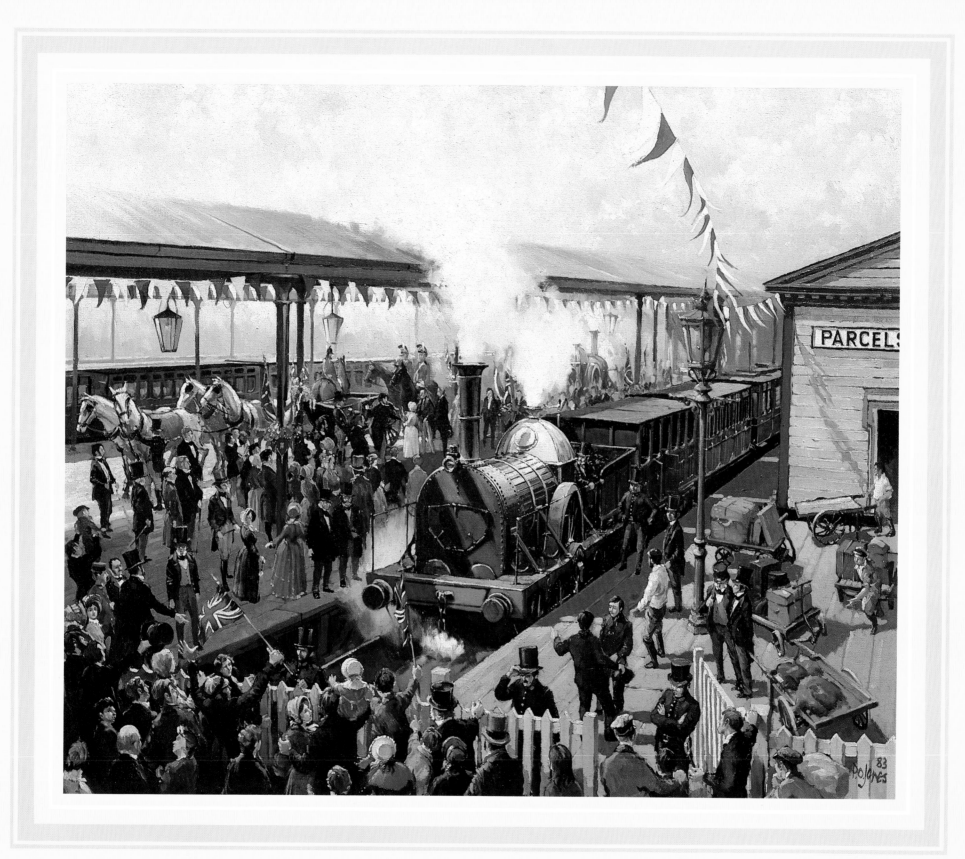

4 *THE ROYAL ROAD* · *P.O.JONES* GRA

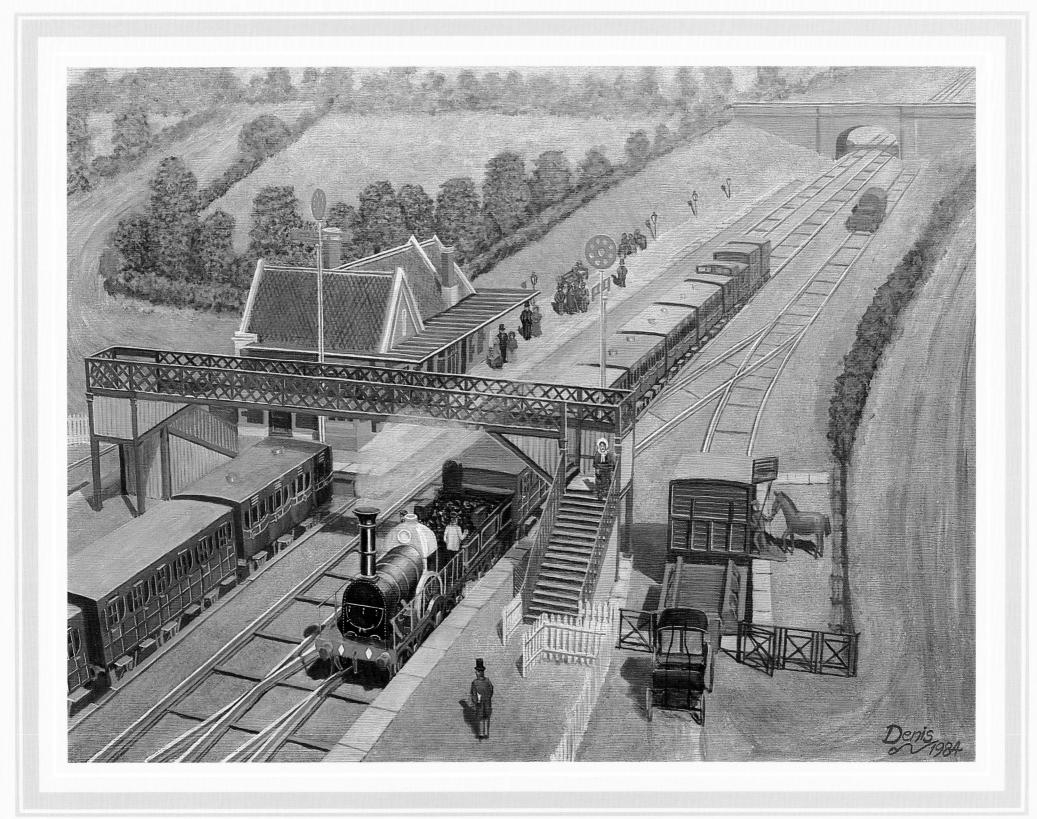

5 GANYMEDE AT TWYFORD · D.G.LEWIS

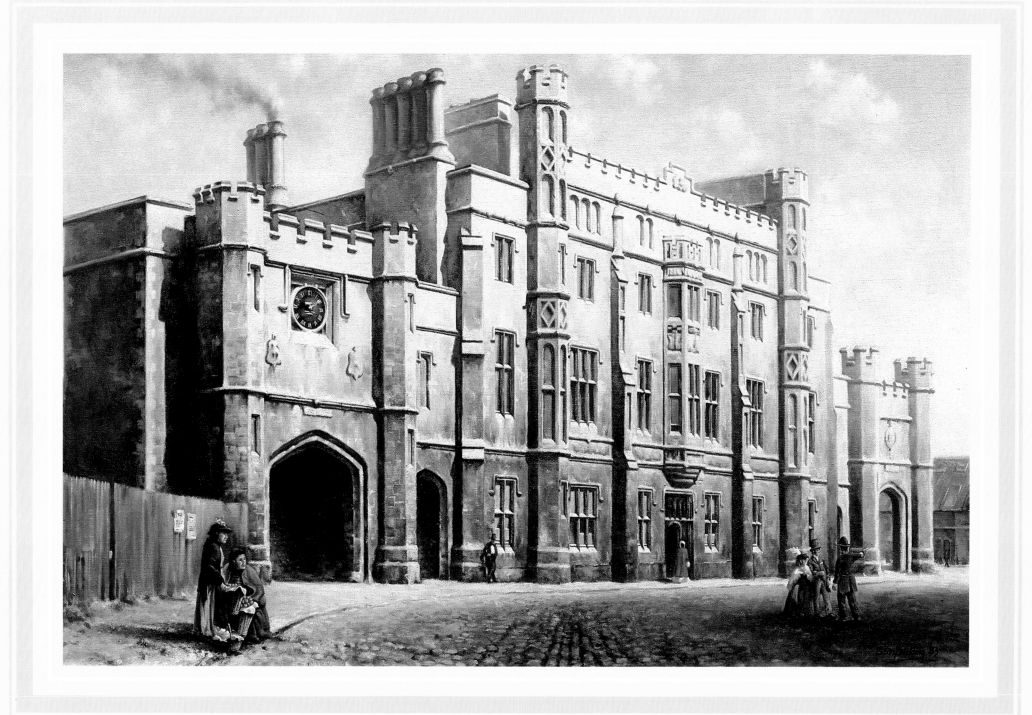

6 TEMPLE GATE, BRISTOL · B.J.WALDING GRA

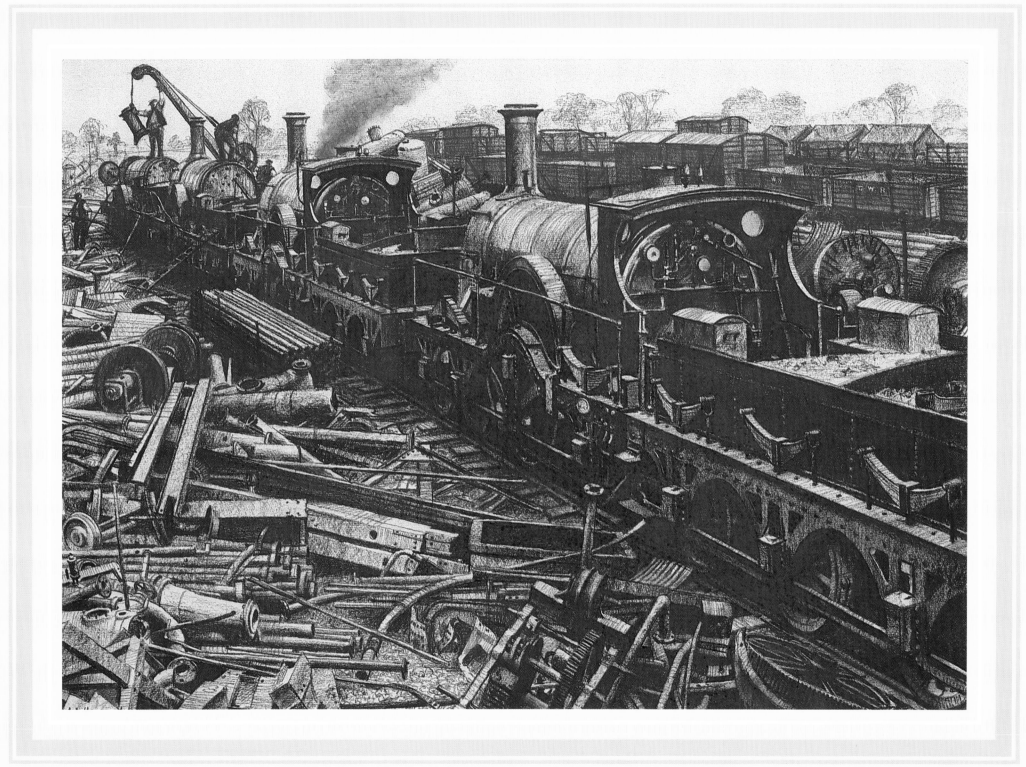

7 *THE BREAKERS YARD – SWINDON AT THE END OF THE BROAD GAUGE,* 1892 · *A.L.HAMMONDS* GRA

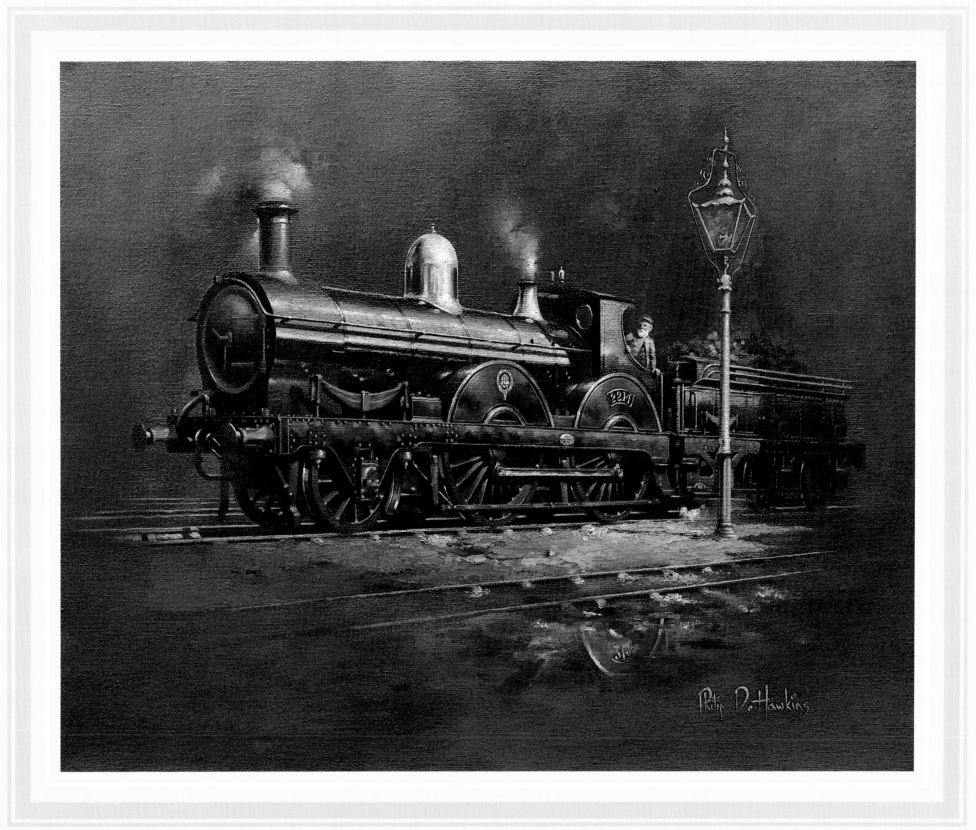

8 COPPER AND BRASS, RED AND GREEN · P.D.HAWKINS GRA

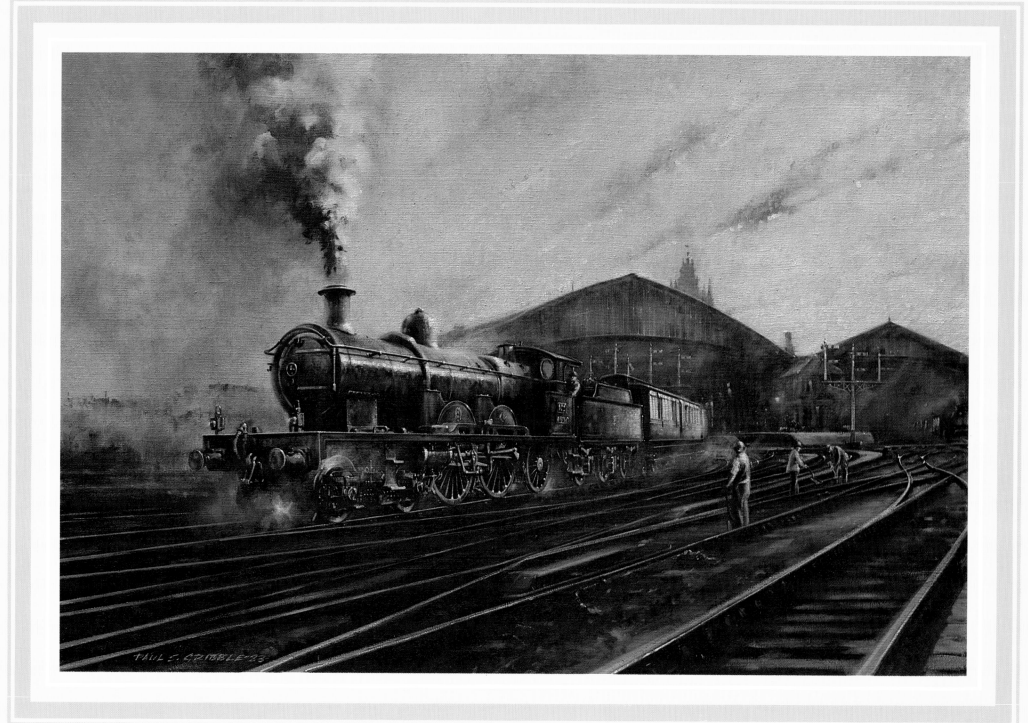

9 '*LA FRANCE*' *circa 1905* · P.S.GRIBBLE GRA

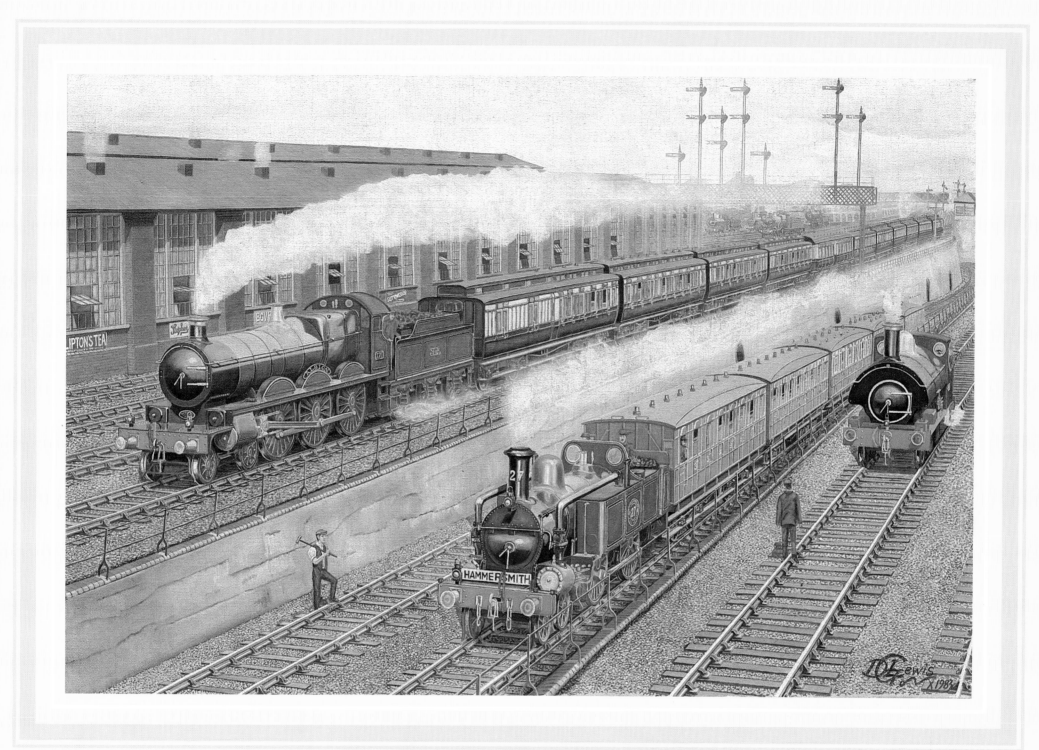

10 *SUBWAY JUNCTION · D.G.LEWIS*

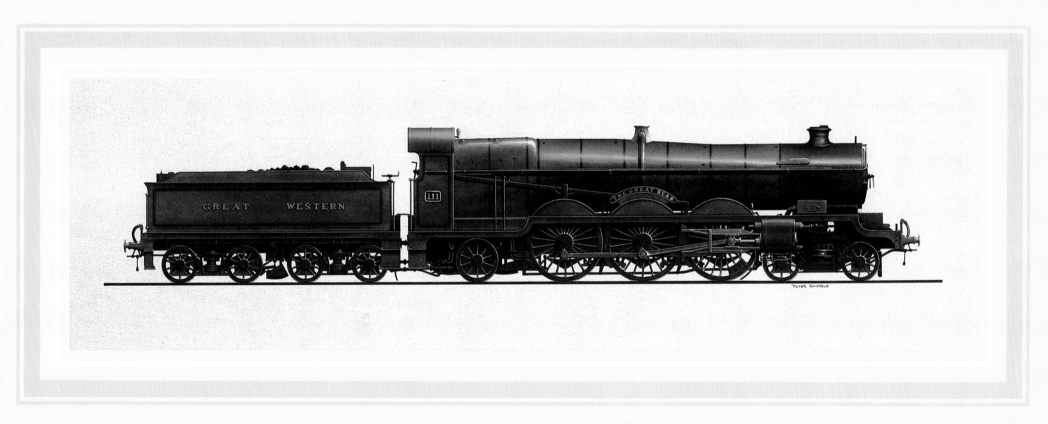

11 THE GREAT BEAR · P.ANNABLE GRA

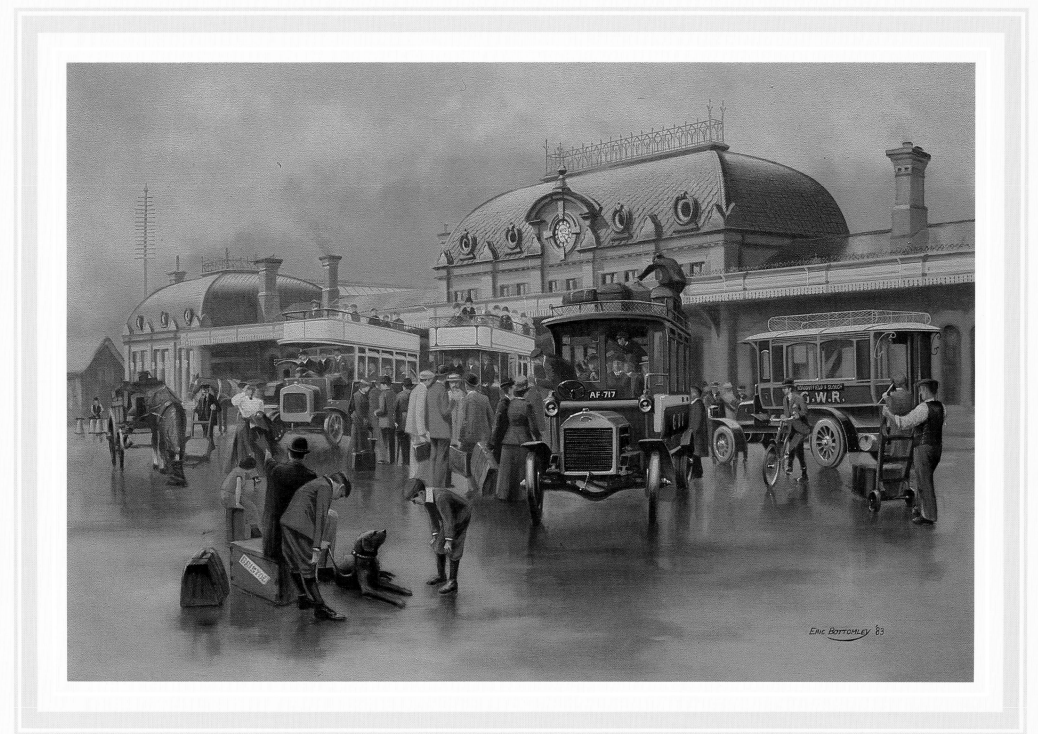

12 *SLOUGH STATION FORECOURT, 1908 · E.BOTTOMLEY*

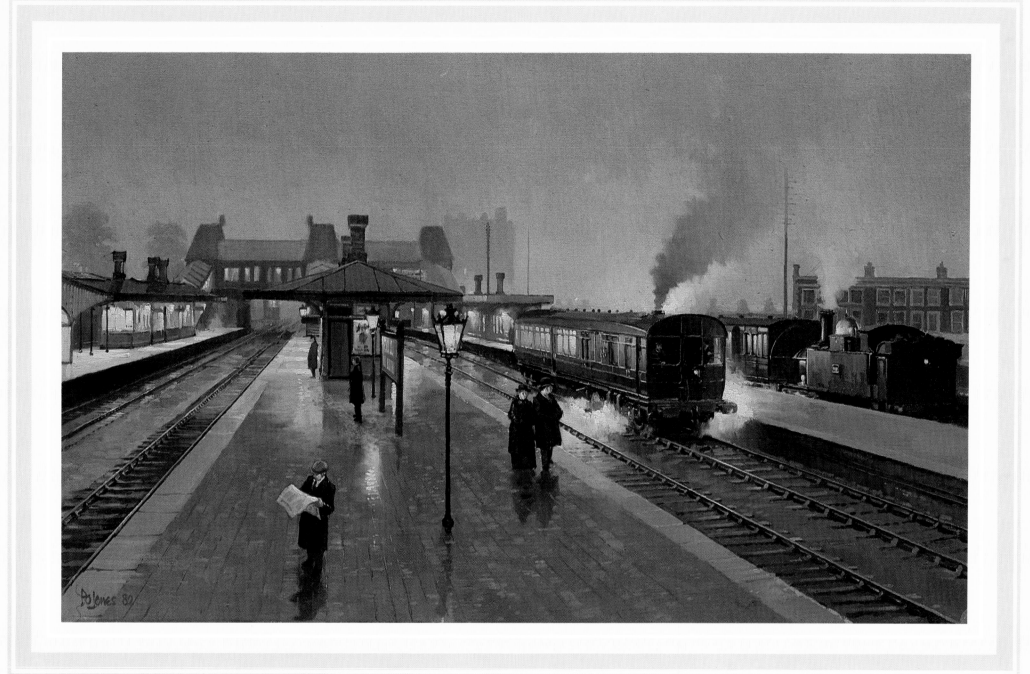

13 *NOVEMBER EVENING, SOUTHALL, circa 1912* · P.O.JONES GRA

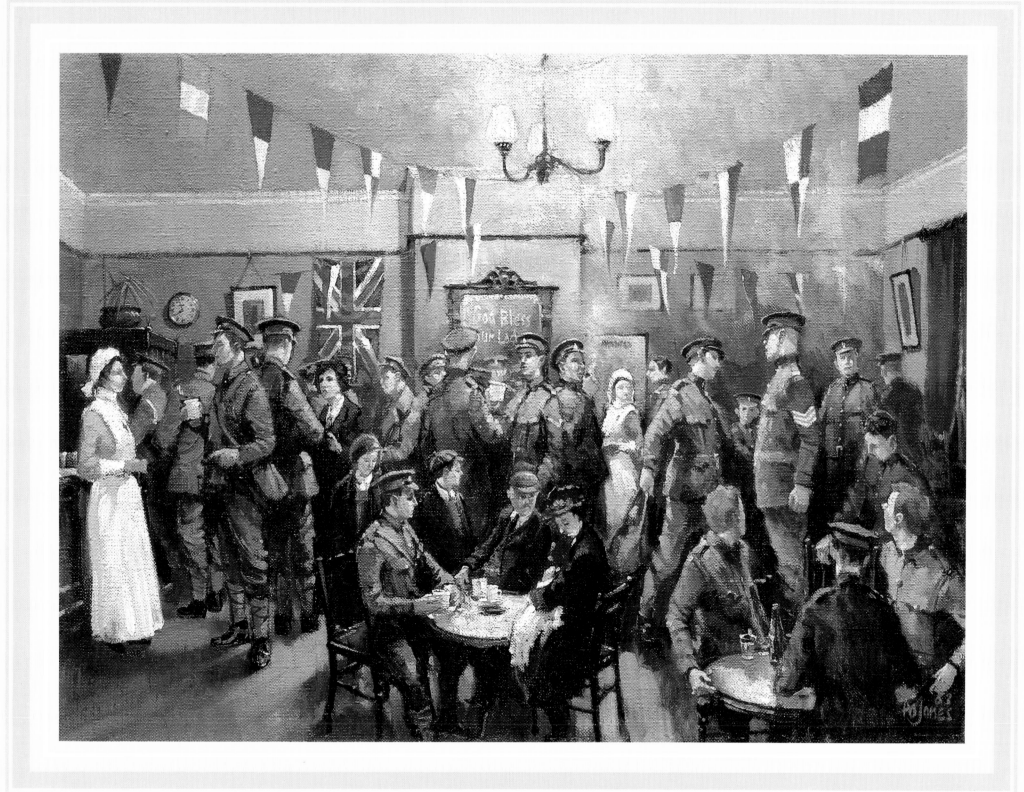

14 GOD BLESS OUR LADS · P.O.JONES GRA

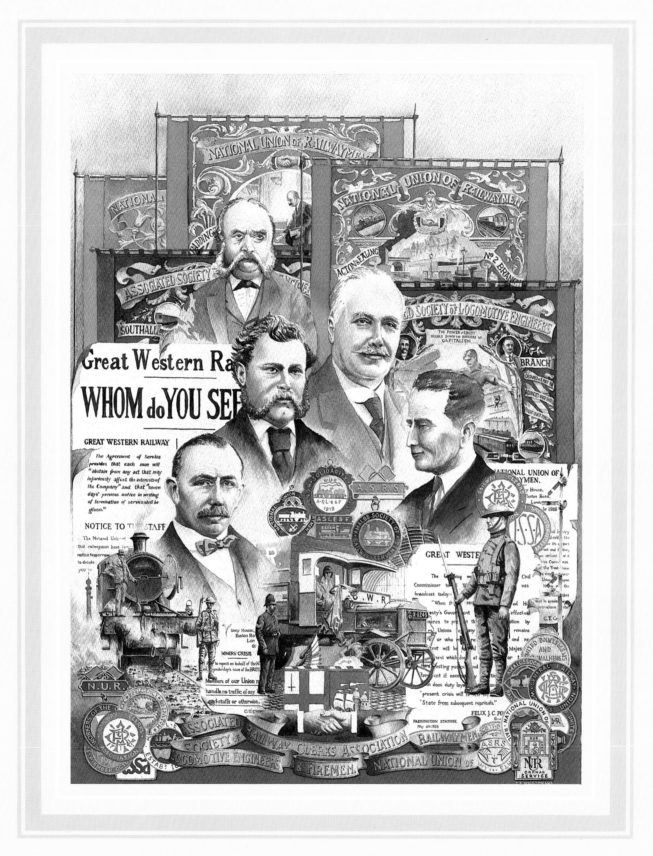

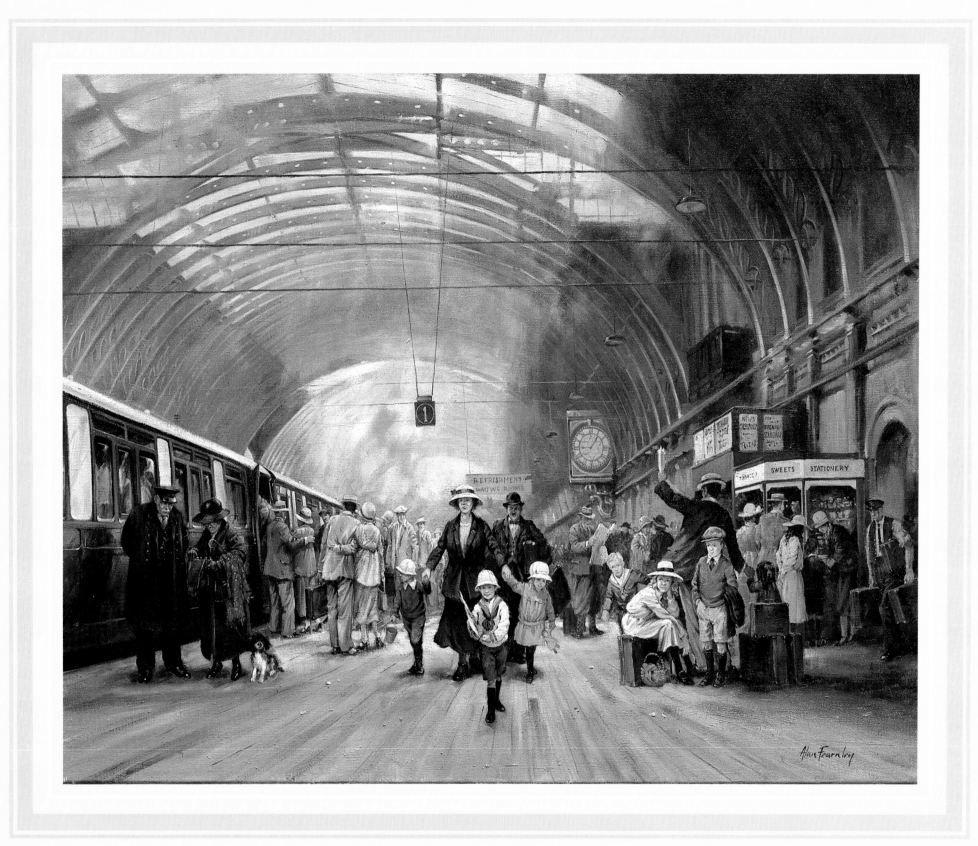

16 *HOLIDAY CROWDS AT PADDINGTON IN THE LATE 1920s* · *A.FEARNLEY* GRA

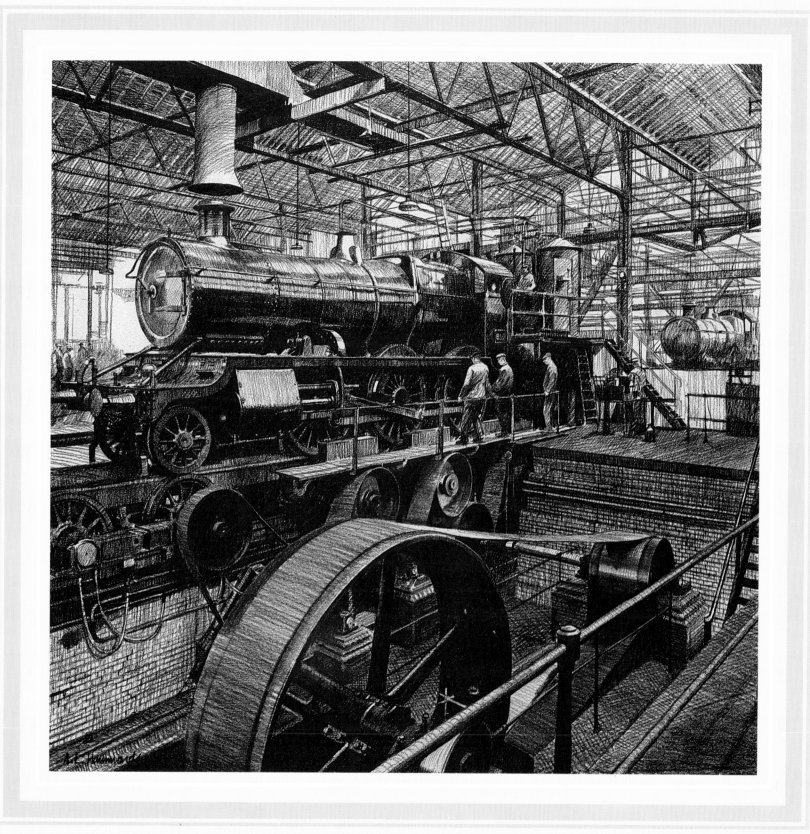

17 *THE TESTING PLANT, SWINDON* · *A.L.HAMMONDS* GRA

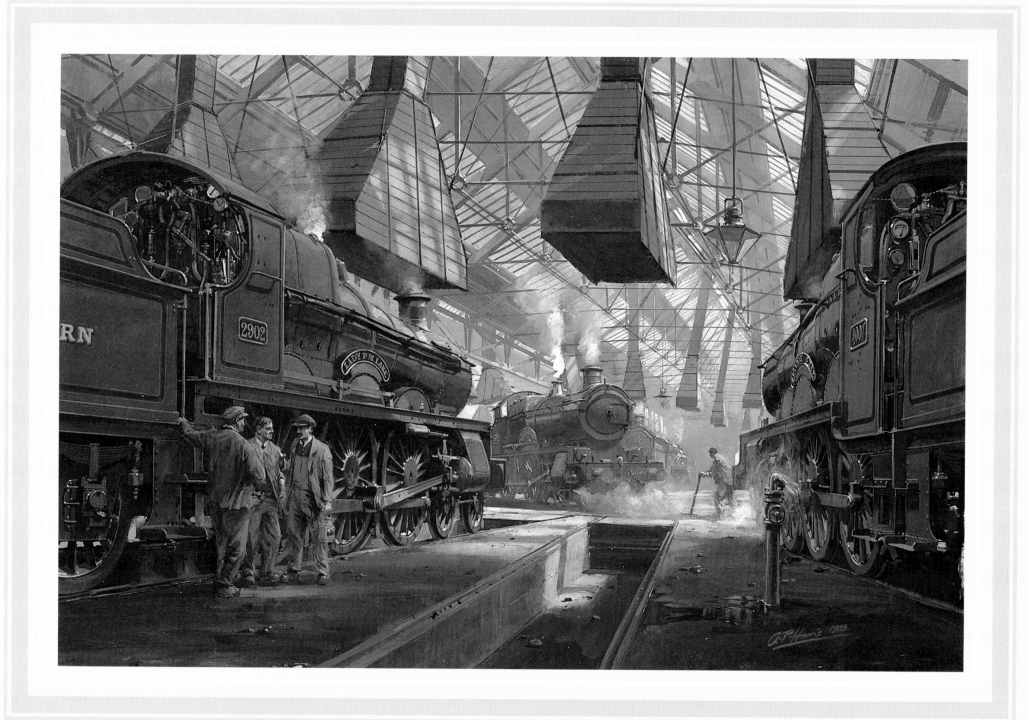

18 *CONVERSATION PIECE – OLD OAK COMMON · A.P.HARRIS* GRA

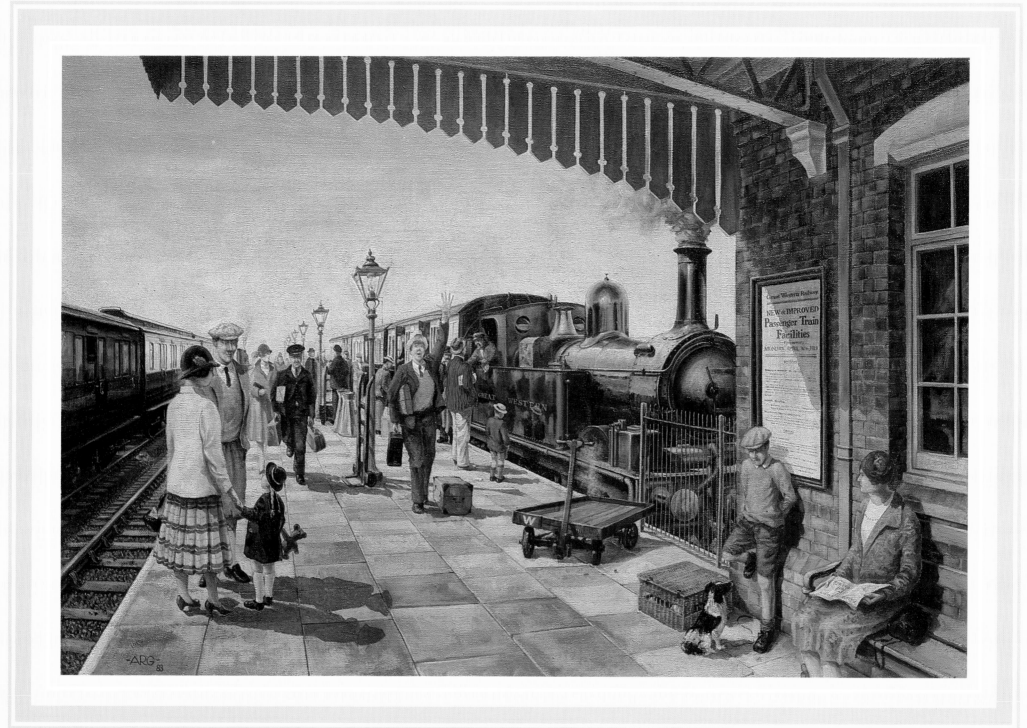

19 BRANCH LINE STEAM – THE BUNK AT CHOLSEY AND MOULSFORD 1929 · A.GUNSTON

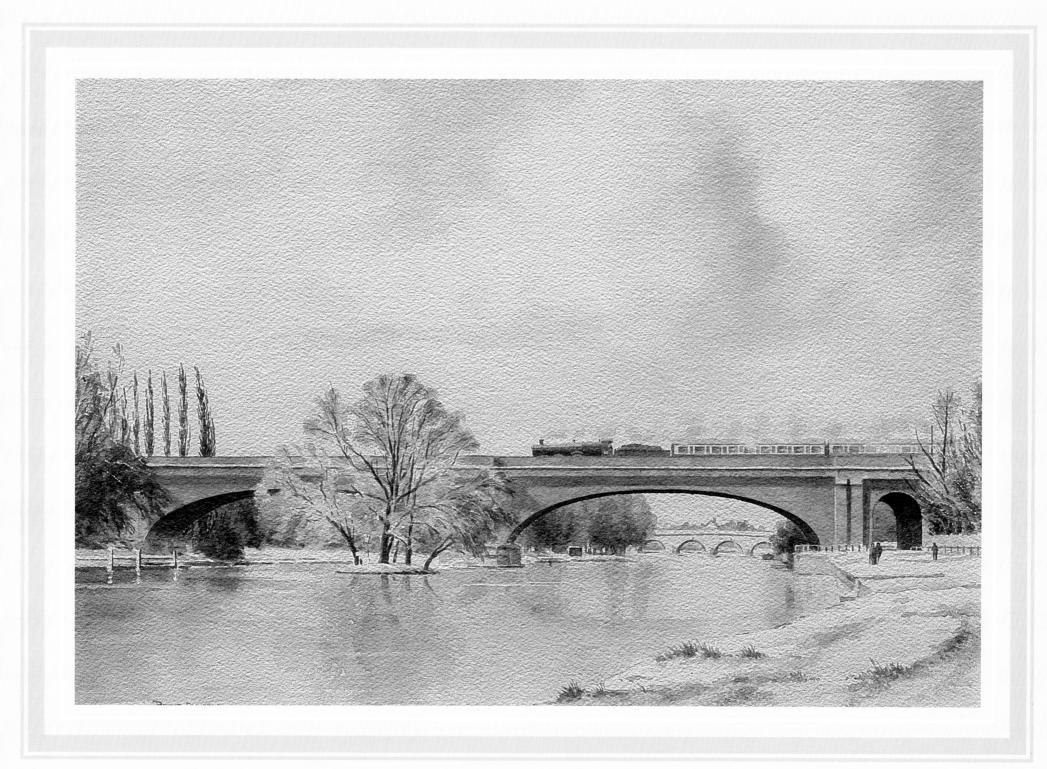

20 *MAIDENHEAD BRIDGE, 1925/30* · P.ANNABLE GRA

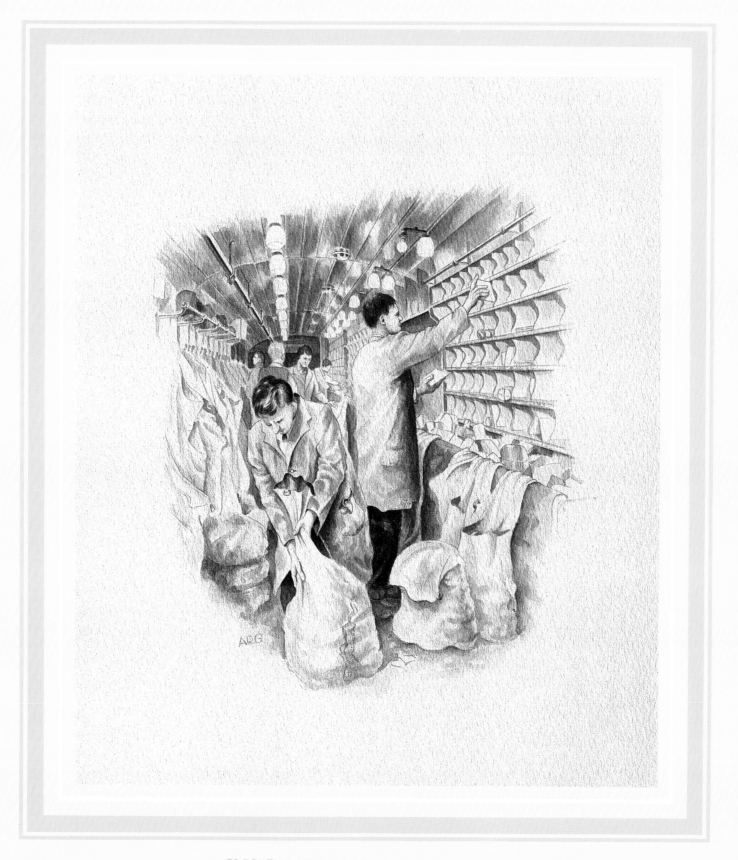

21 INSIDE THE T.P.O. · A.GUNSTON

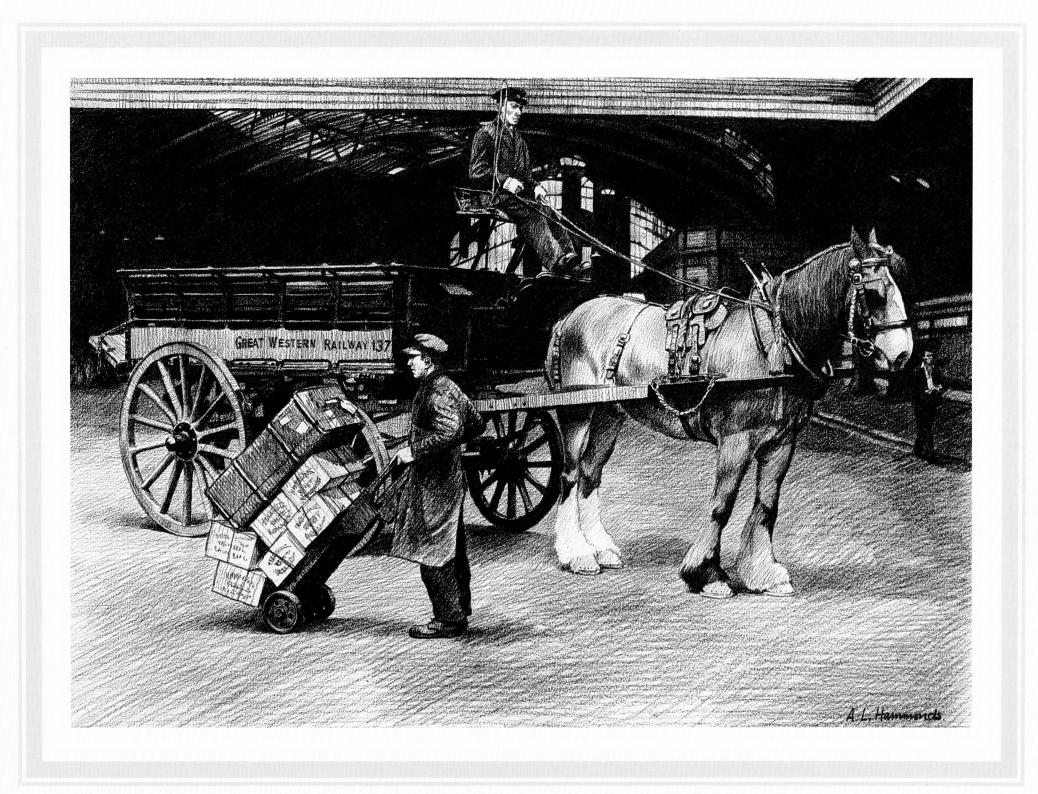

22 *HORSE DRAWN PARCELS WAGON – PADDINGTON STATION* · *A.L.HAMMONDS* GRA

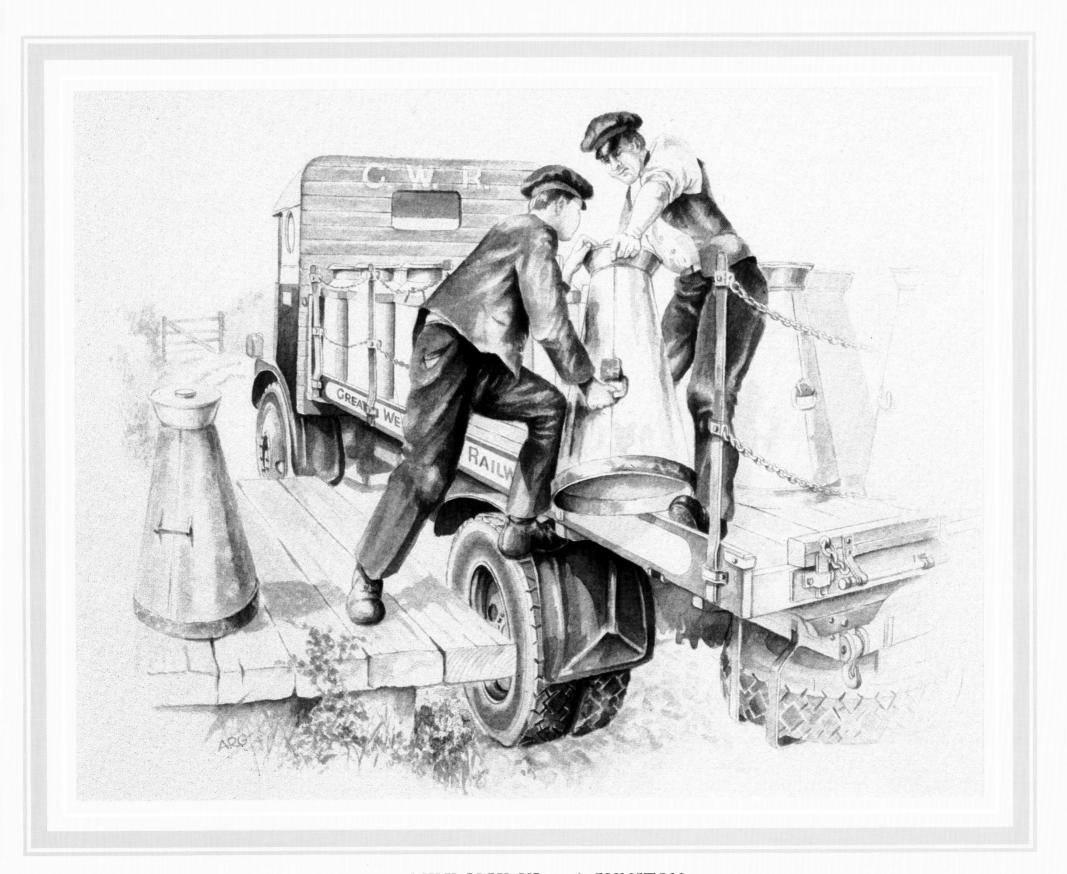

23 *MILK PICK-UP · A.GUNSTON*

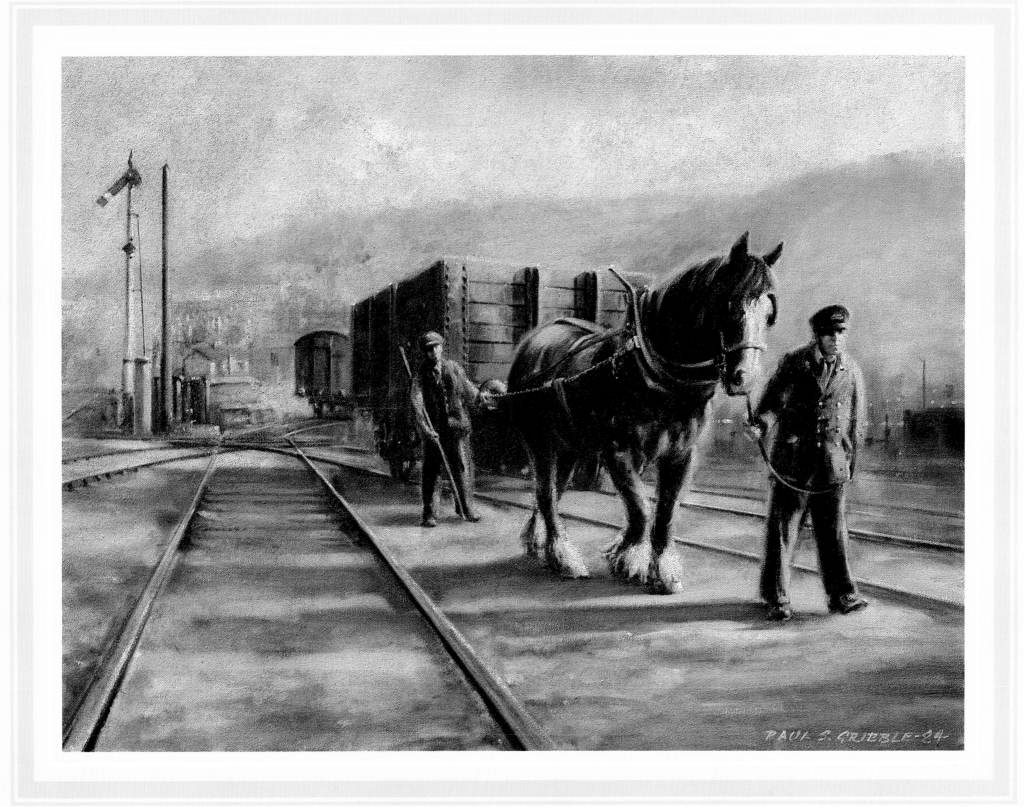

24 *HORSE SHUNTING — BATH · P.S.GRIBBLE* GRA

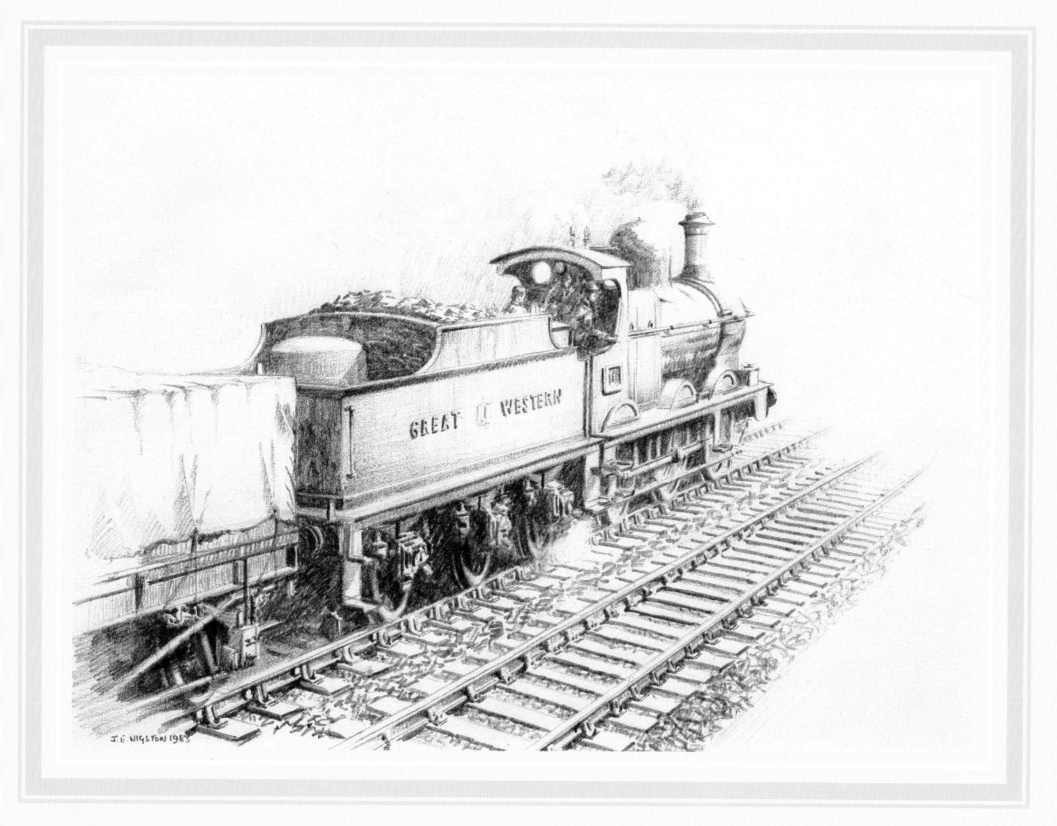

25 DEAN GOODS · J.E.WIGSTON GRA

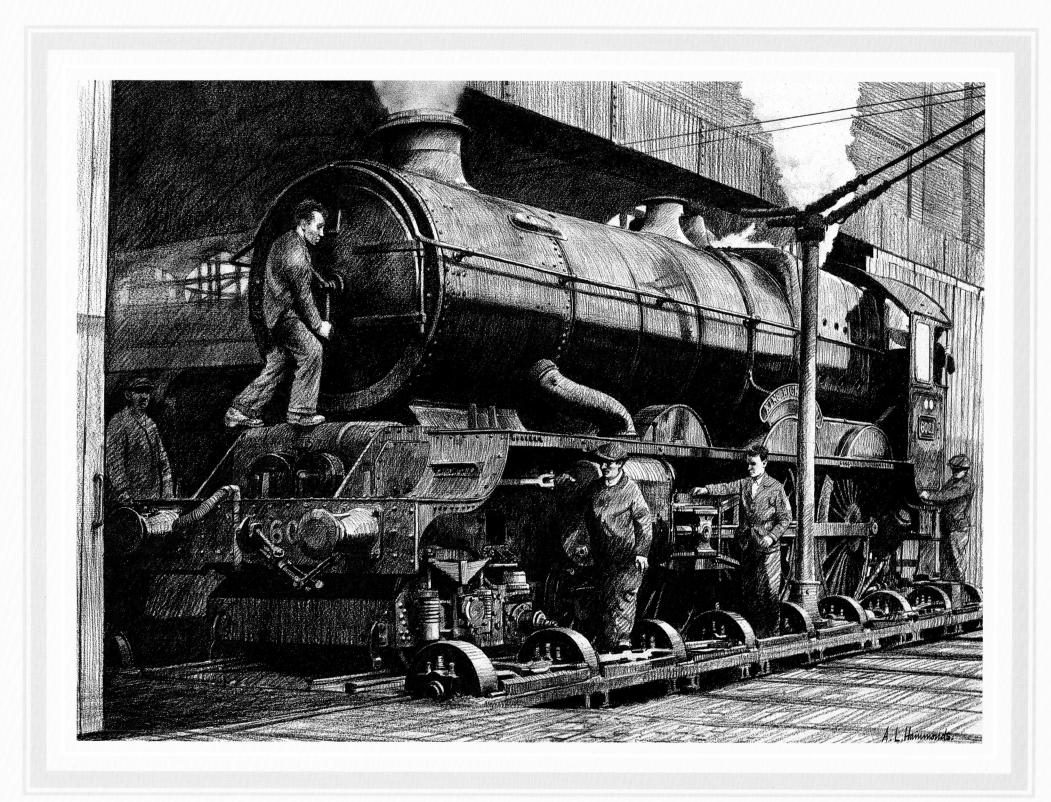

26 *THE TRAVERSER, SWINDON* · A.L.HAMMONDS GRA

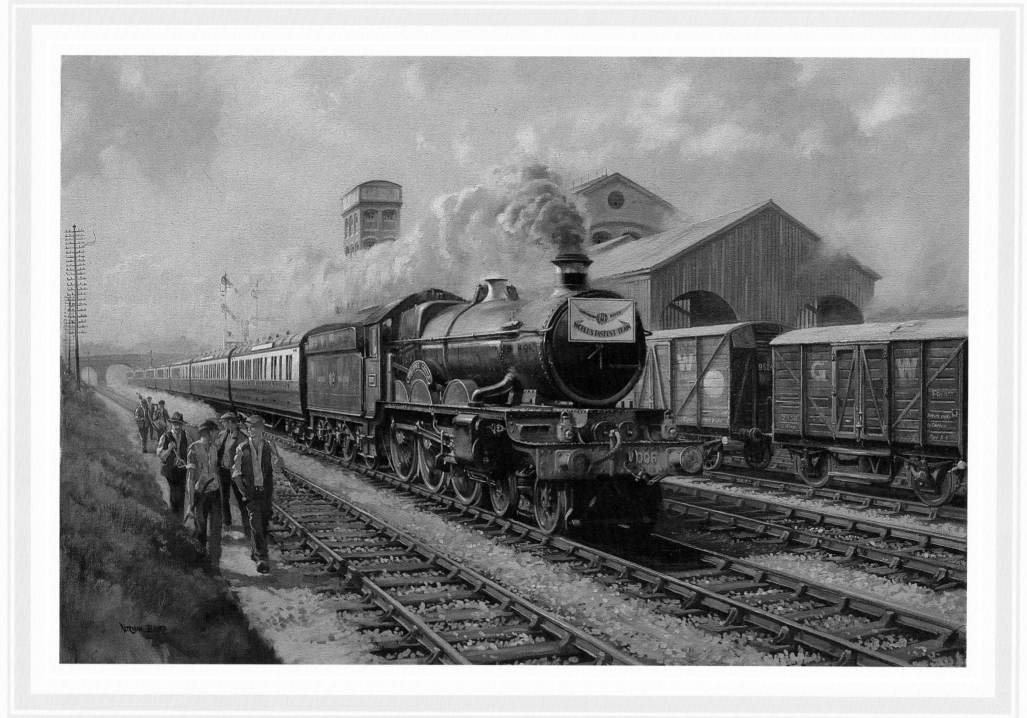

27 THE CHELTENHAM FLYER · N.ELFORD GRA

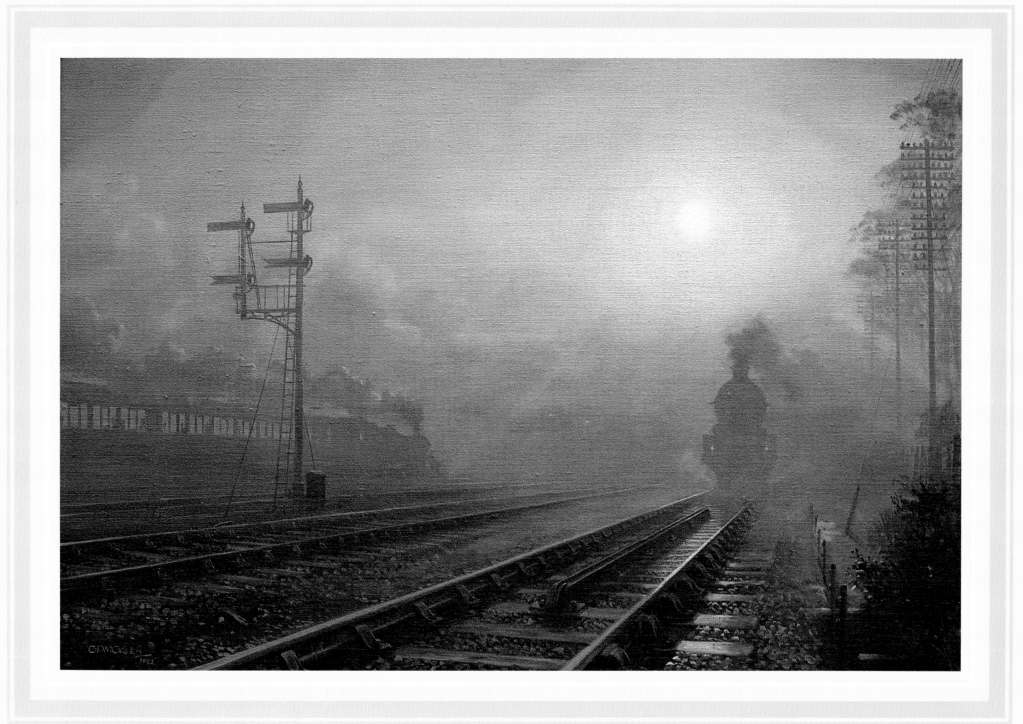

28 *SAFELY FAST · G.P.M.GREEN* GRA

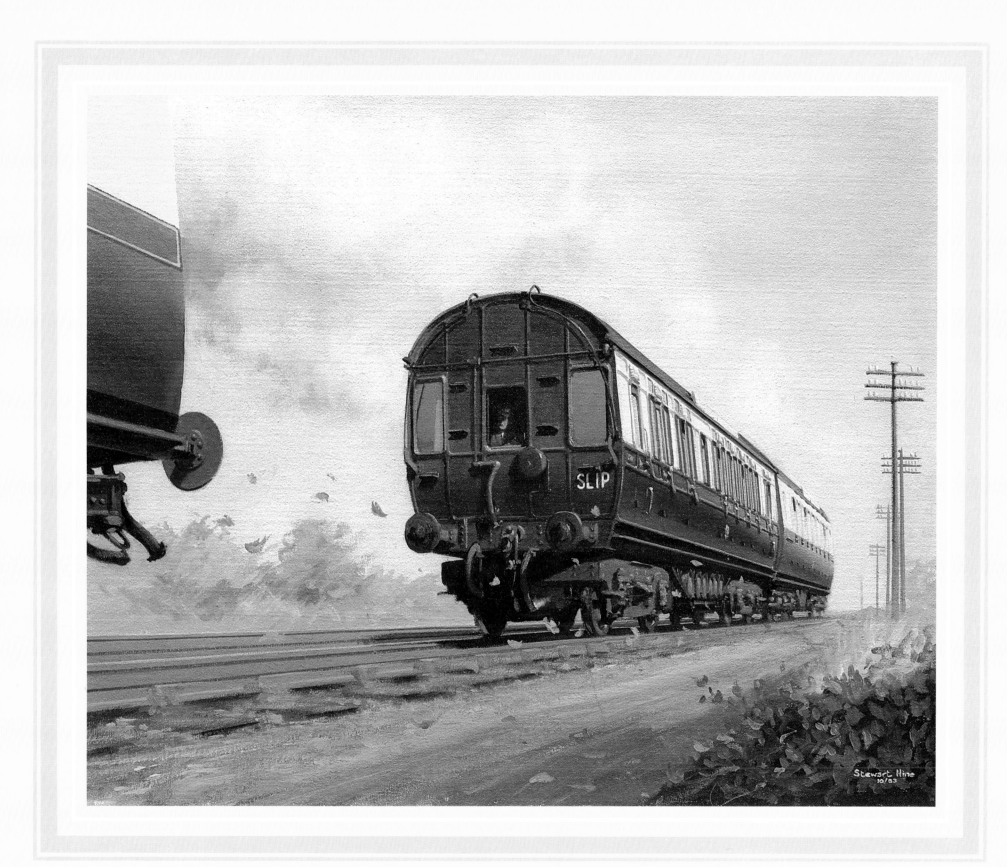

29 SLIP · S.C.HINE

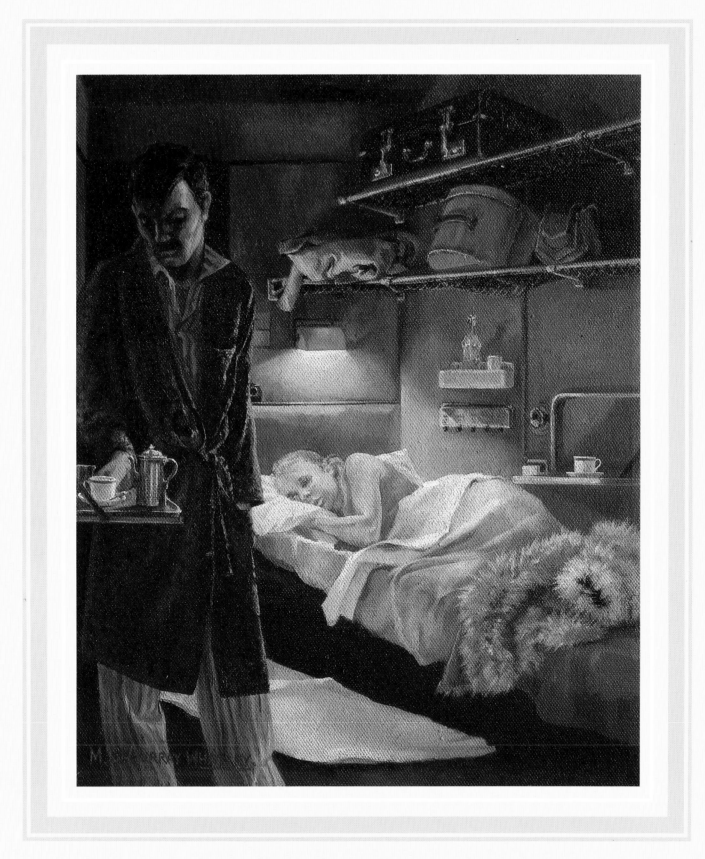

30 GOOD MORNING DEAR · MRS.M.S.MURRAY-WHATLEY GRA

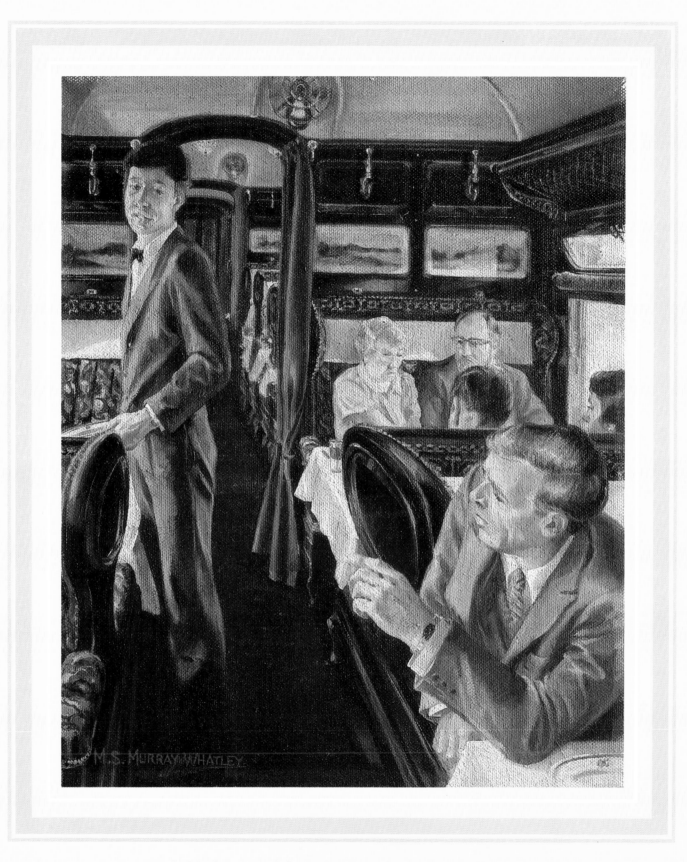

31 WAITER · MRS.M.S.MURRAY-WHATLEY GRA

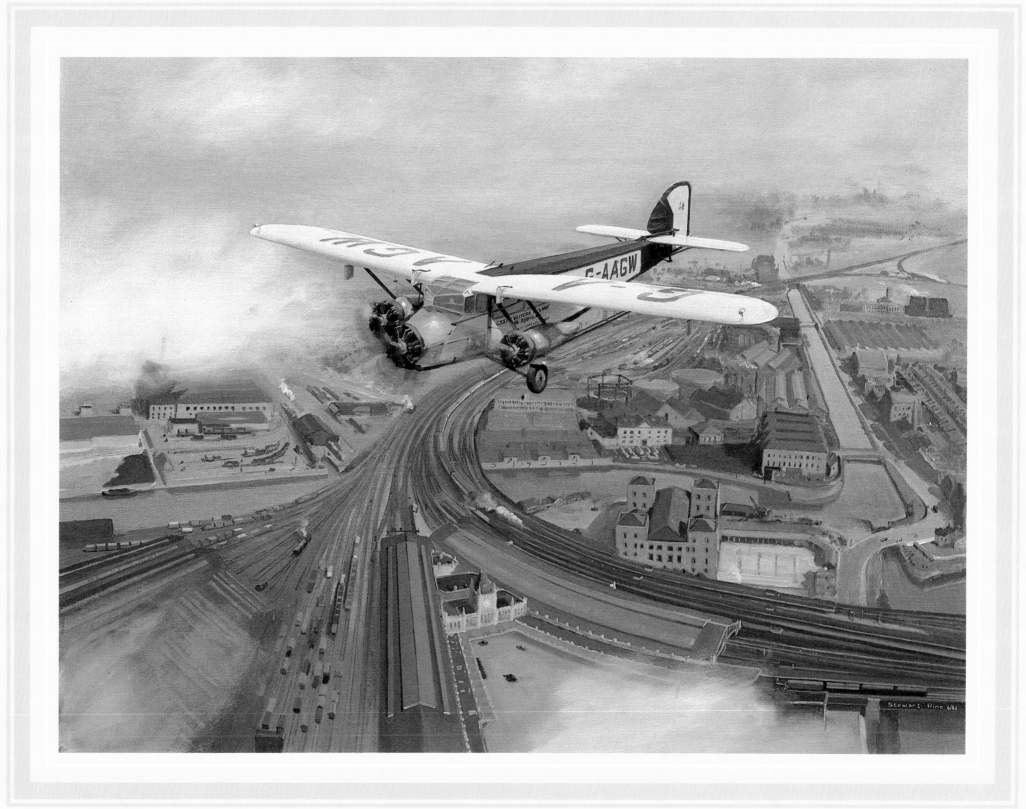

32 *RAILS IN THE SKY · S.C.HINE*

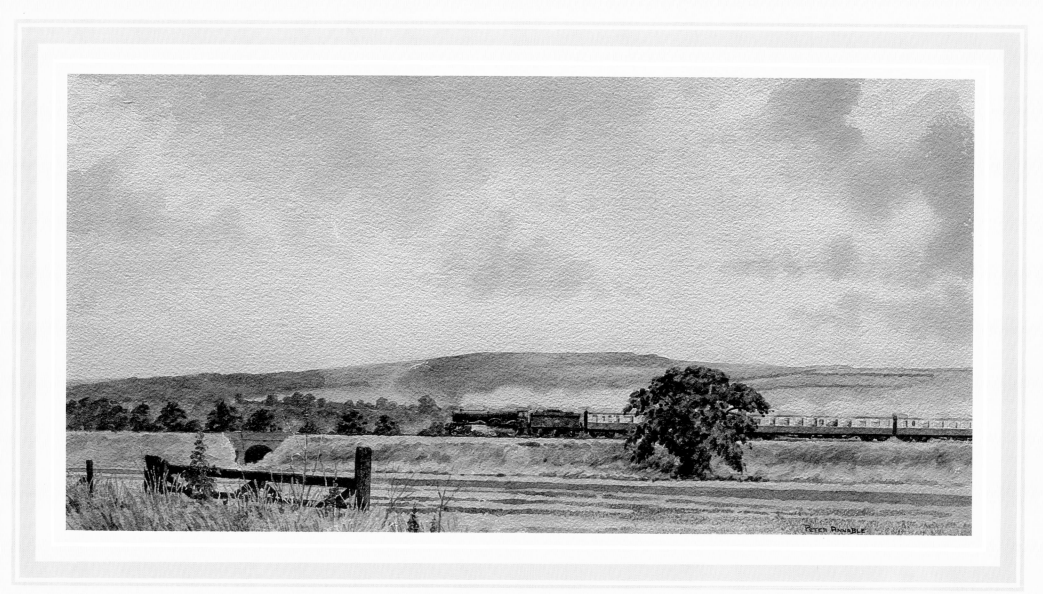

33 *VALE OF THE WHITE HORSE* · *P.ANNABLE* GRA

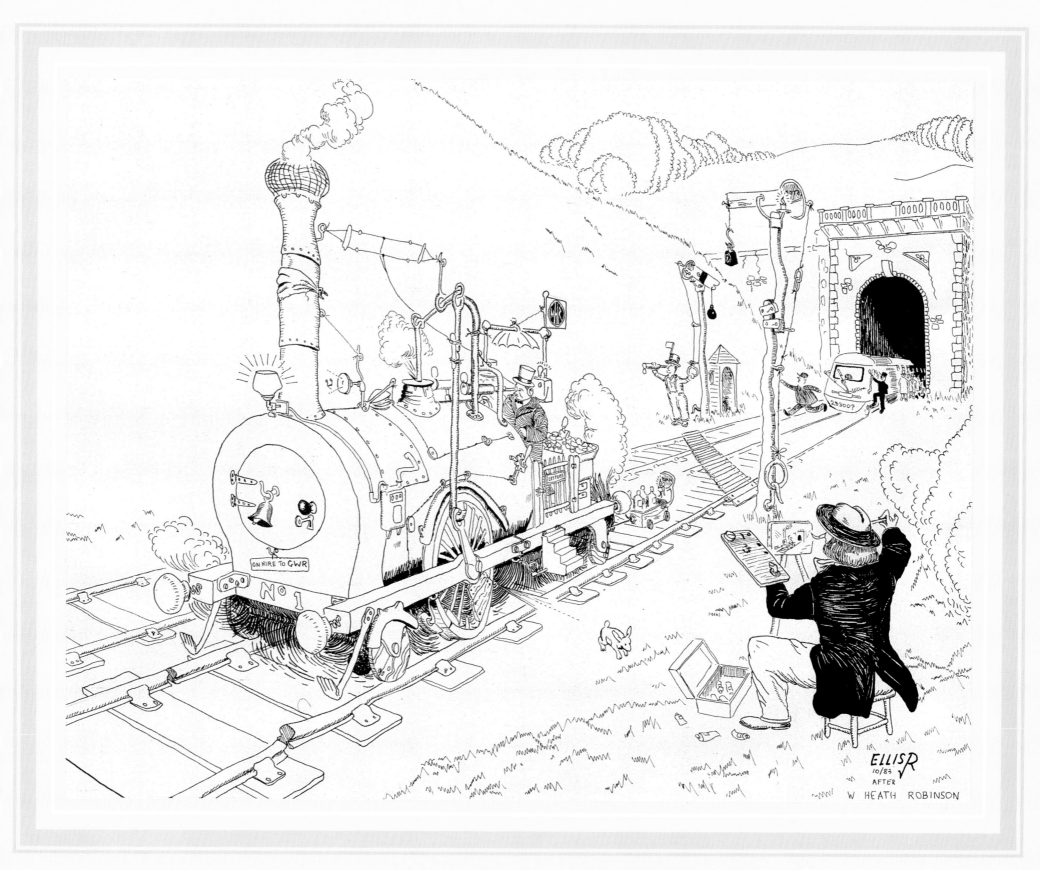

34 *AFTER HEATH-ROBINSON · R.E.JAMES-ROBERTSON*

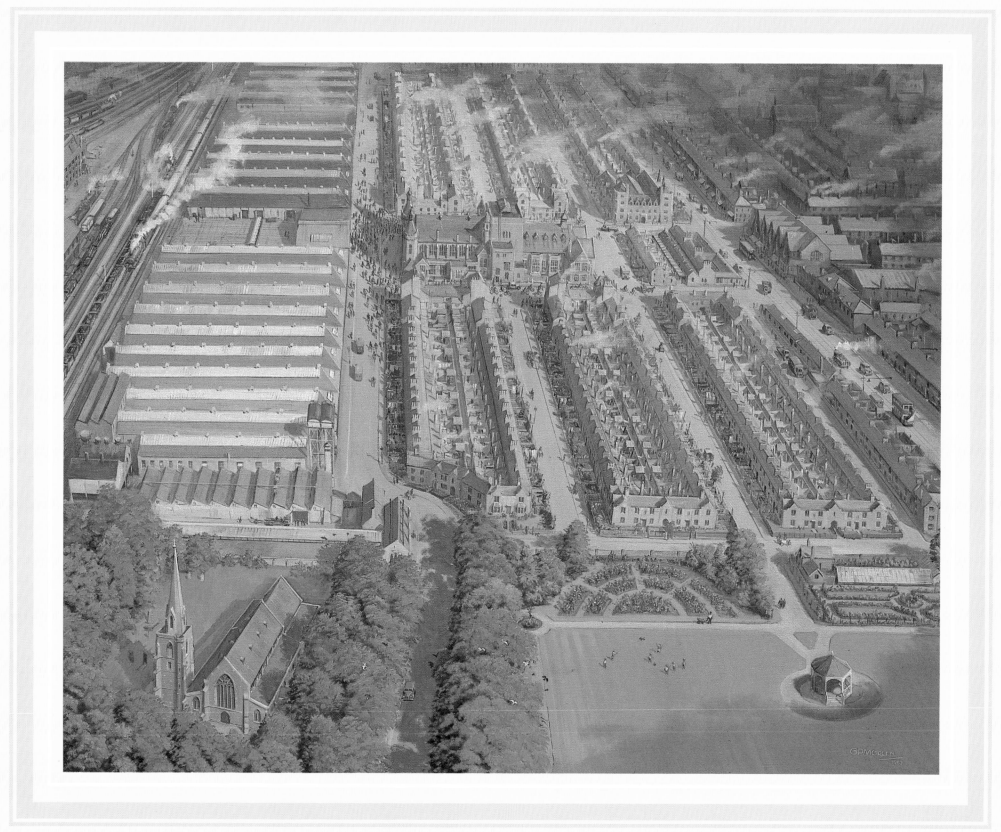

35 SWINDON RAILWAY VILLAGE, circa 1935 · G.P.M.GREEN GRA

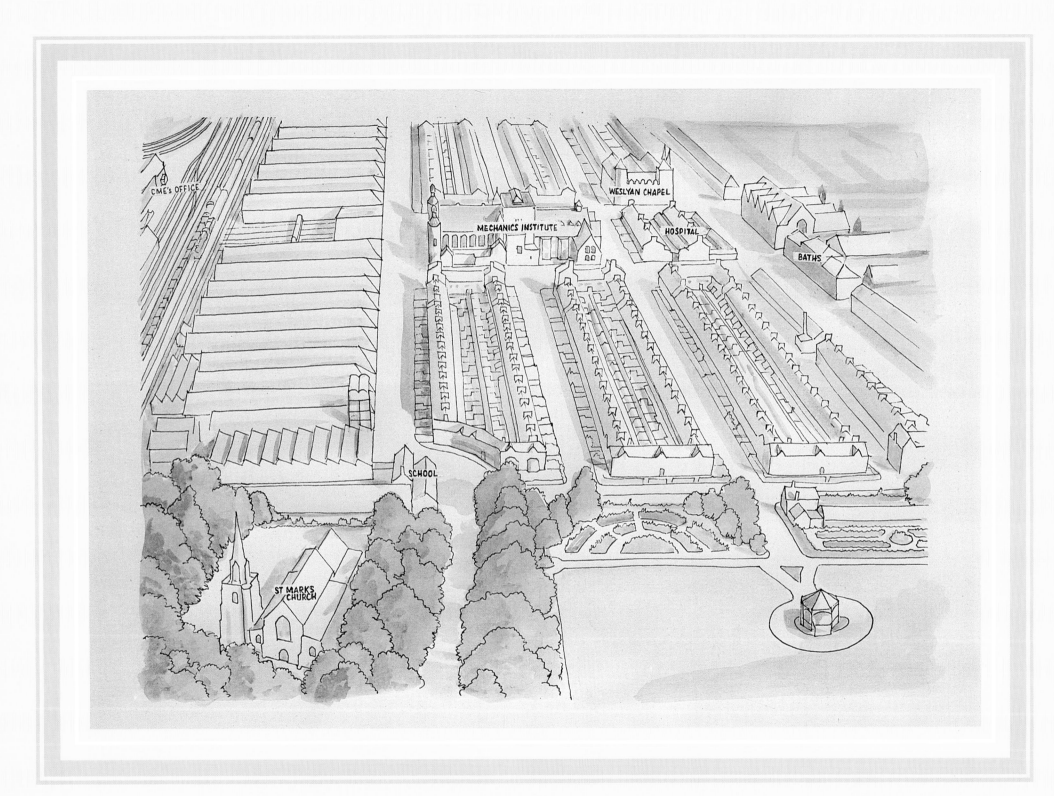

The labels visible in the image:
- CME's OFFICE
- MECHANICS INSTITUTE
- WESLYAN CHAPEL
- HOSPITAL
- BATHS
- SCHOOL
- ST MARK'S CHURCH

35a KEY TO PAINTING NO.35

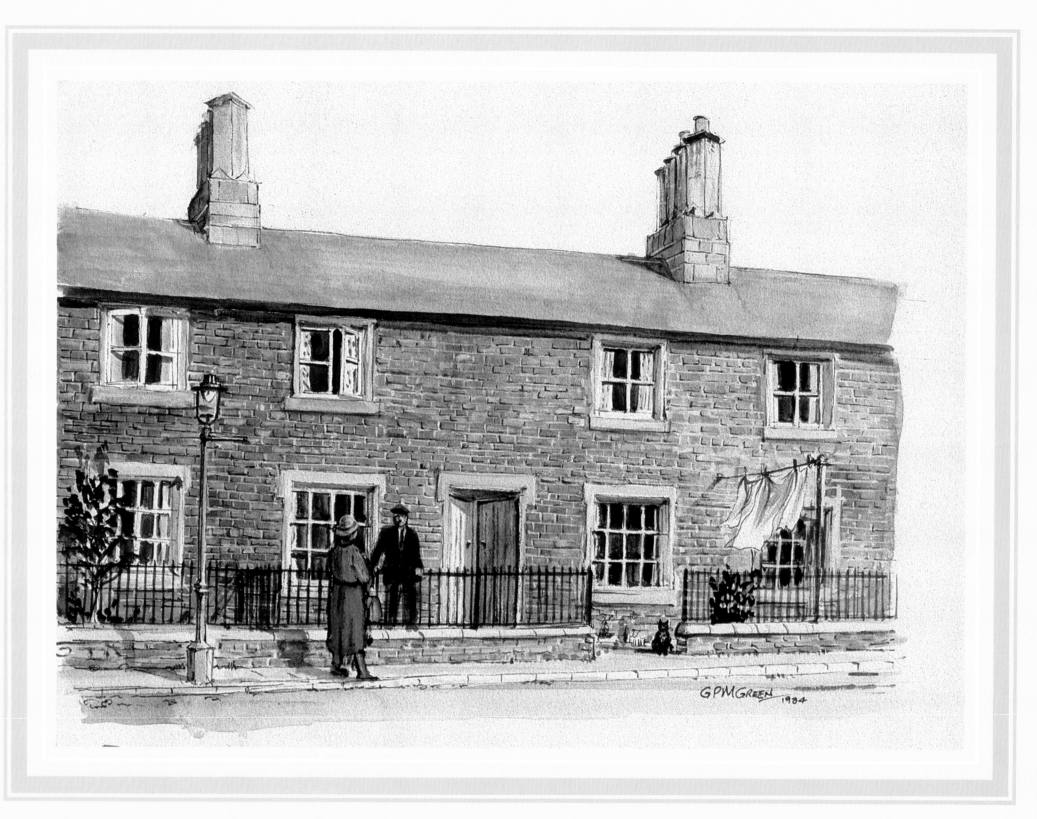

36 *TYPICAL WORKMAN'S HOUSE, SWINDON* · *G.P.M.GREEN* GRA

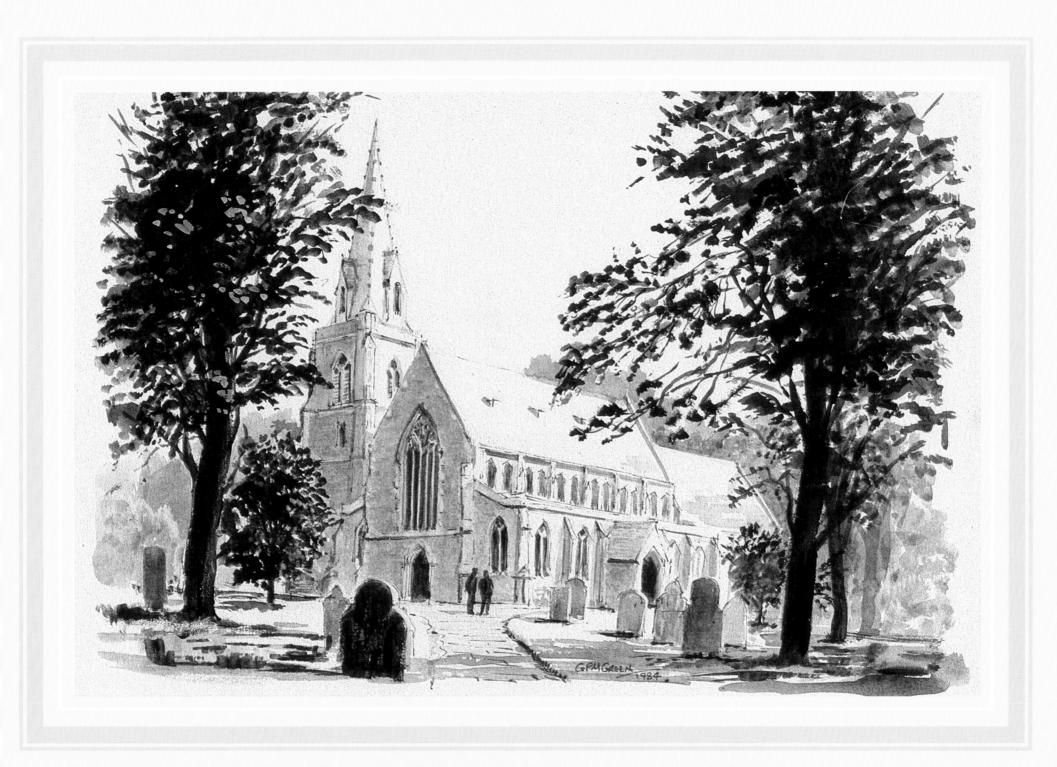

37 ST.MARK'S CHURCH, SWINDON · G.P.M.GREEN GRA

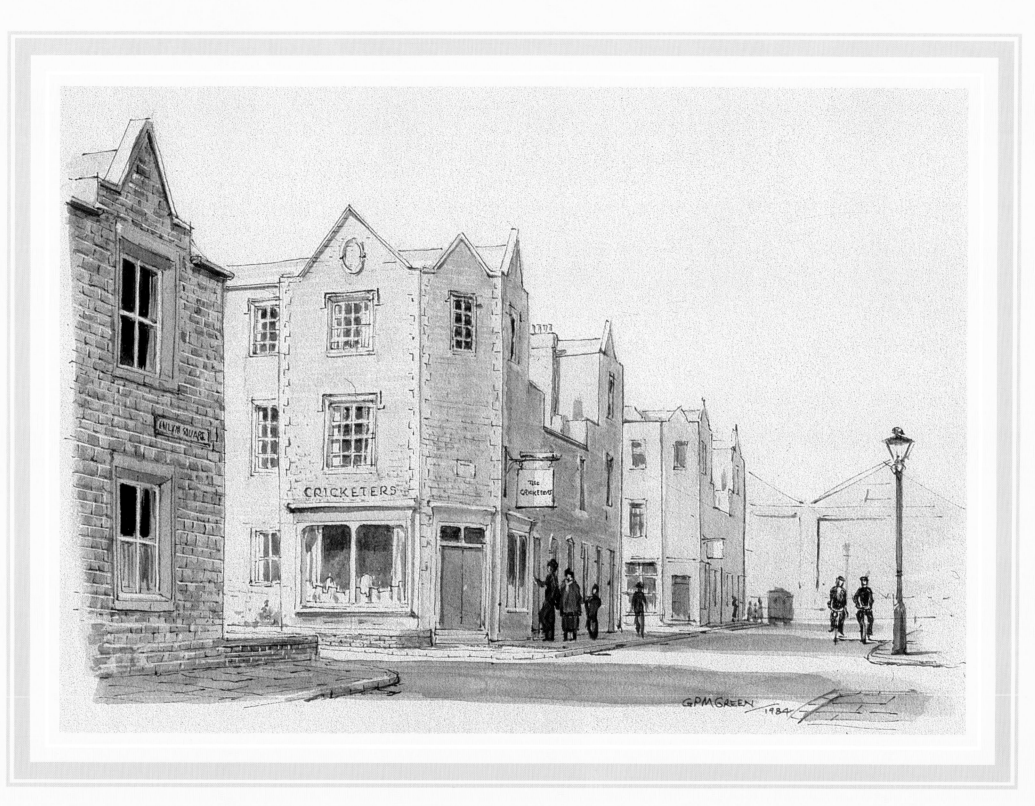

38 THE CRICKETER'S ARMS AND THE BAKER'S ARMS, SWINDON · G.P.M.GREEN GRA

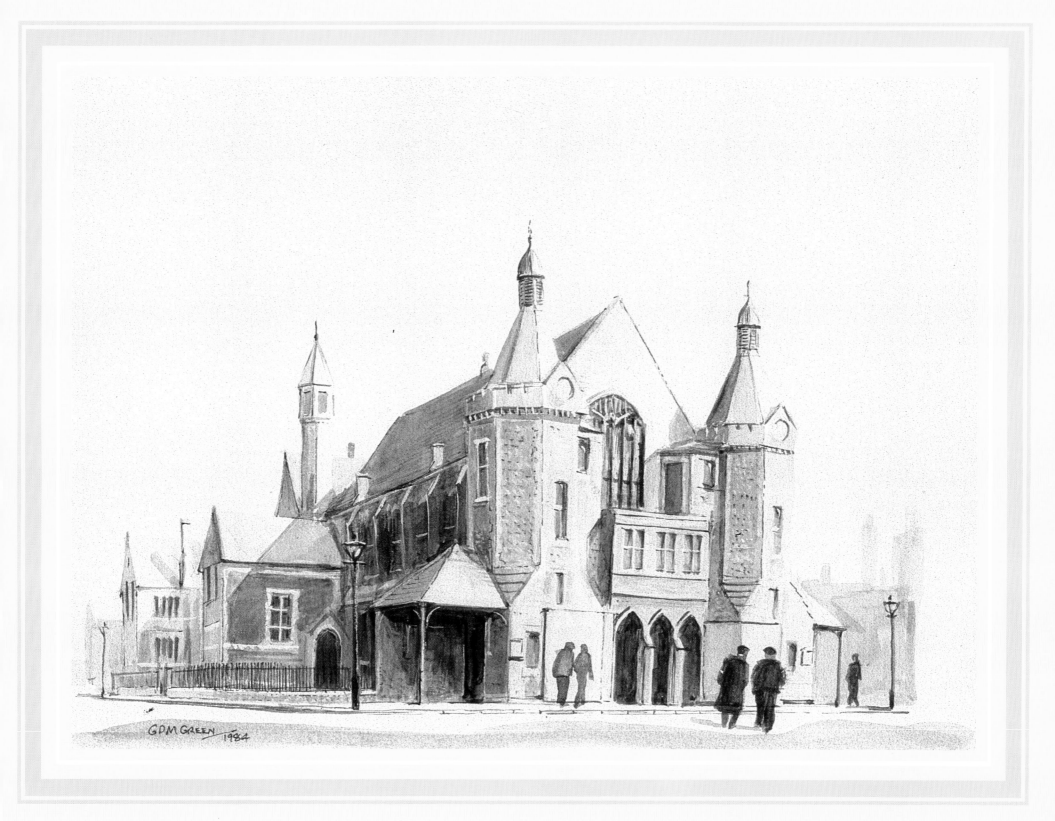

39 *THE MECHANIC'S INSTITUTE SWINDON (BEFORE THE FIRE)* · *G.P.M.GREEN* GRA

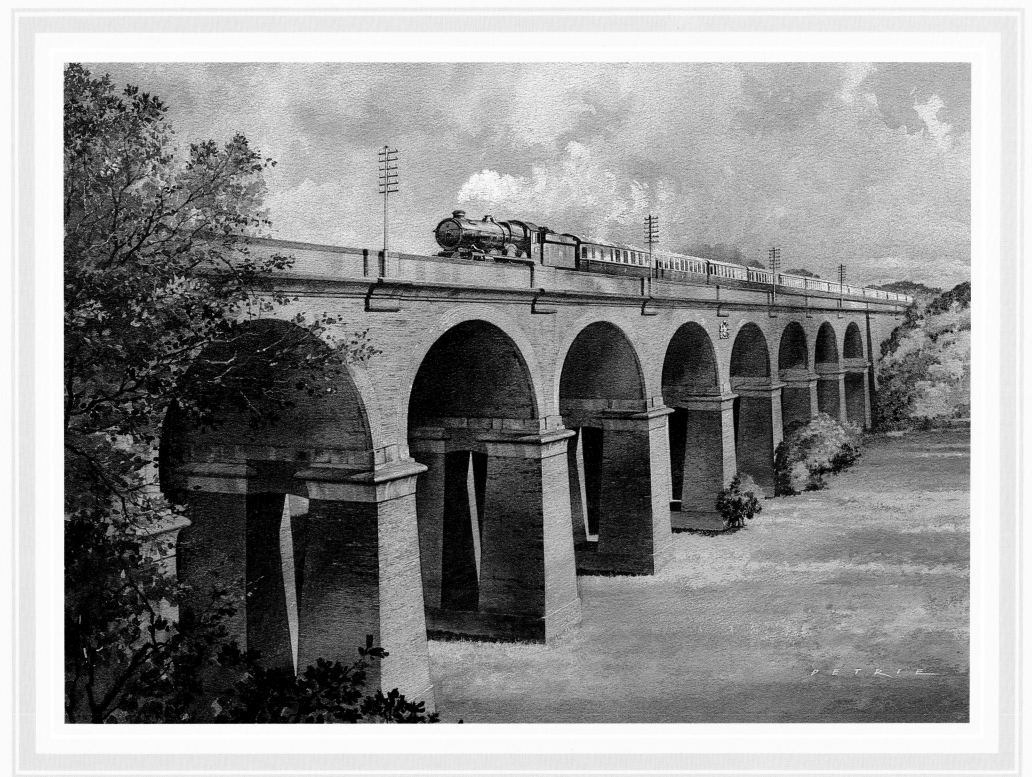

40　*WHARNCLIFFE VIADUCT · J.W.PETRIE* GRA

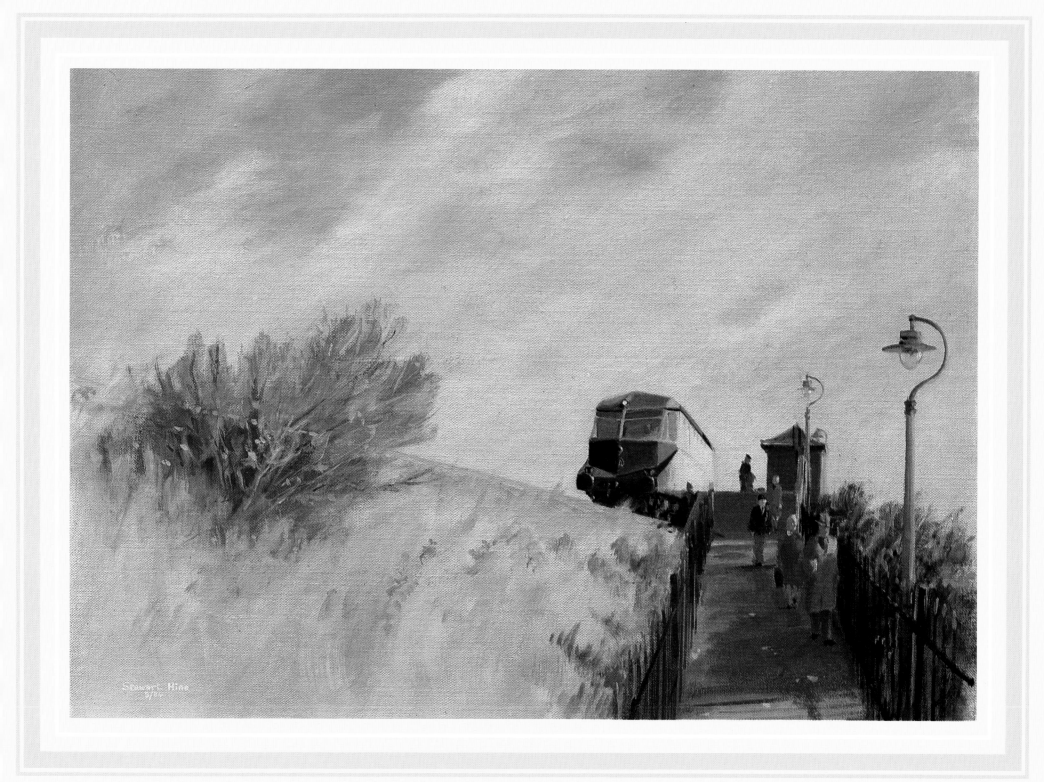

41 *SUBURBAN SHUTTLE · S.C.HINE*

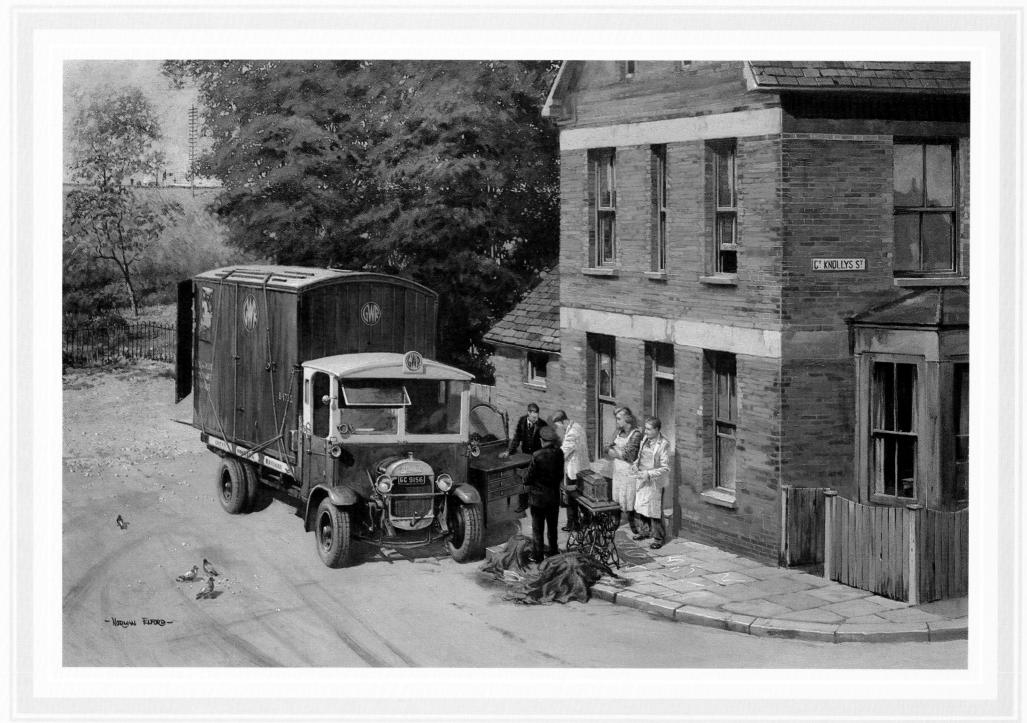

42 MOVING DAY · N.ELFORD *GRA*

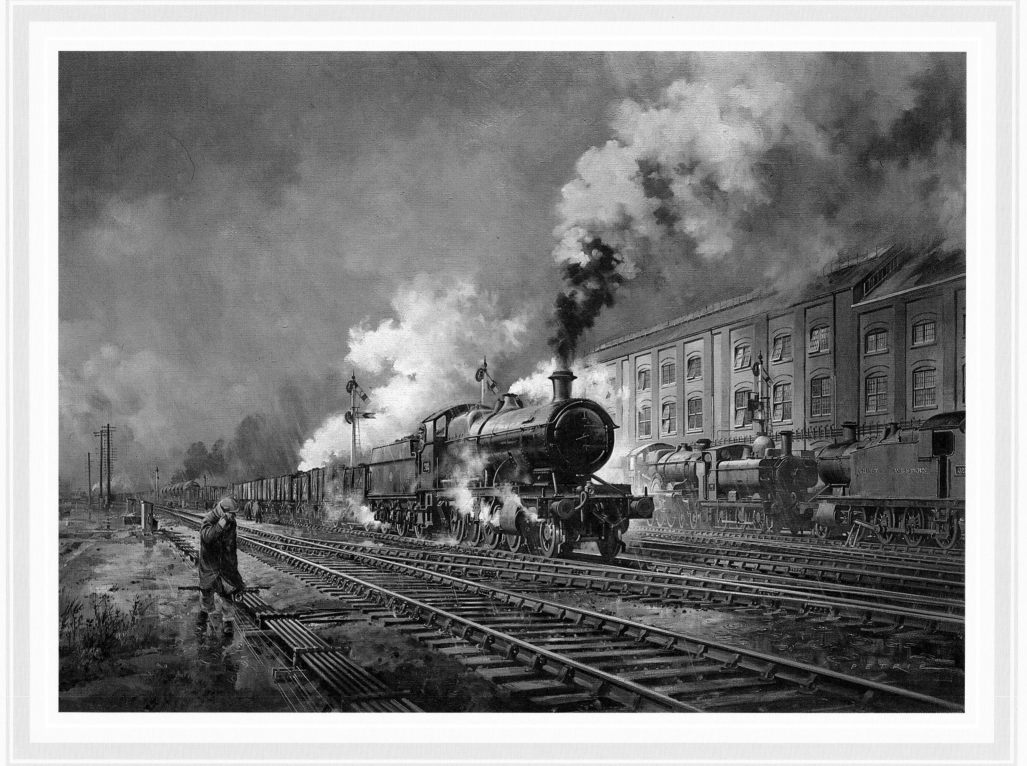

43 SURE FOOTED · J.W.PETRIE GRA

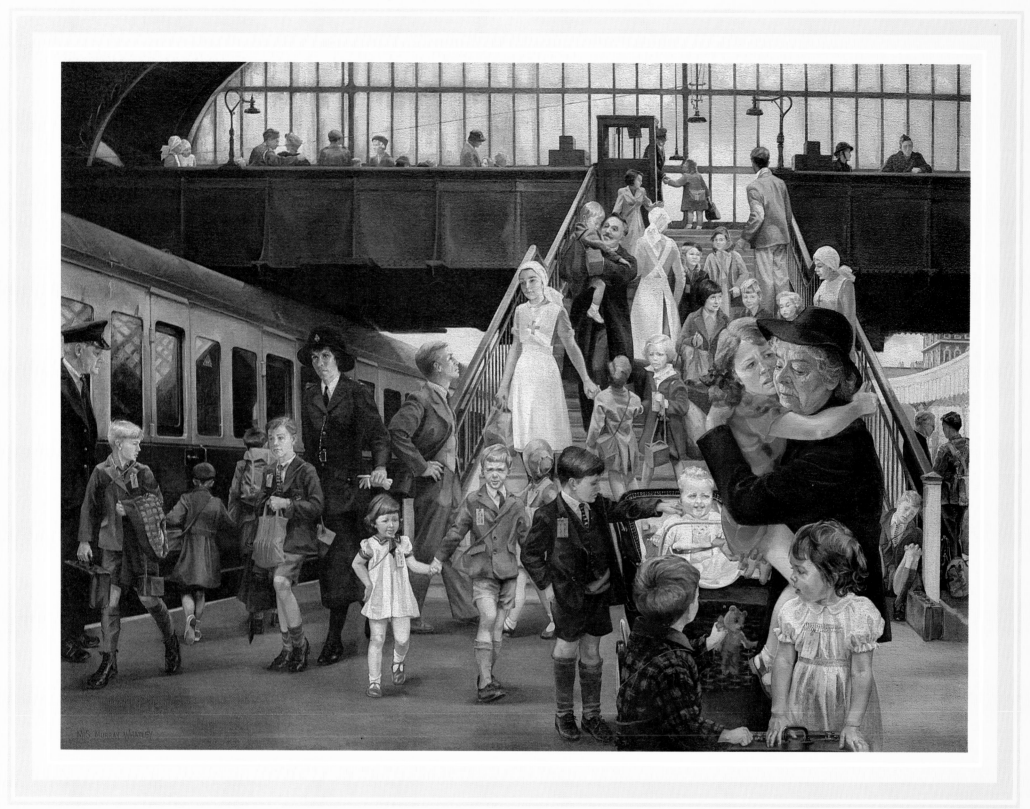

44 *EVACUEES LEAVE PADDINGTON, circa 1940 · MRS.M.S.MURRAY-WHATLEY* GRA

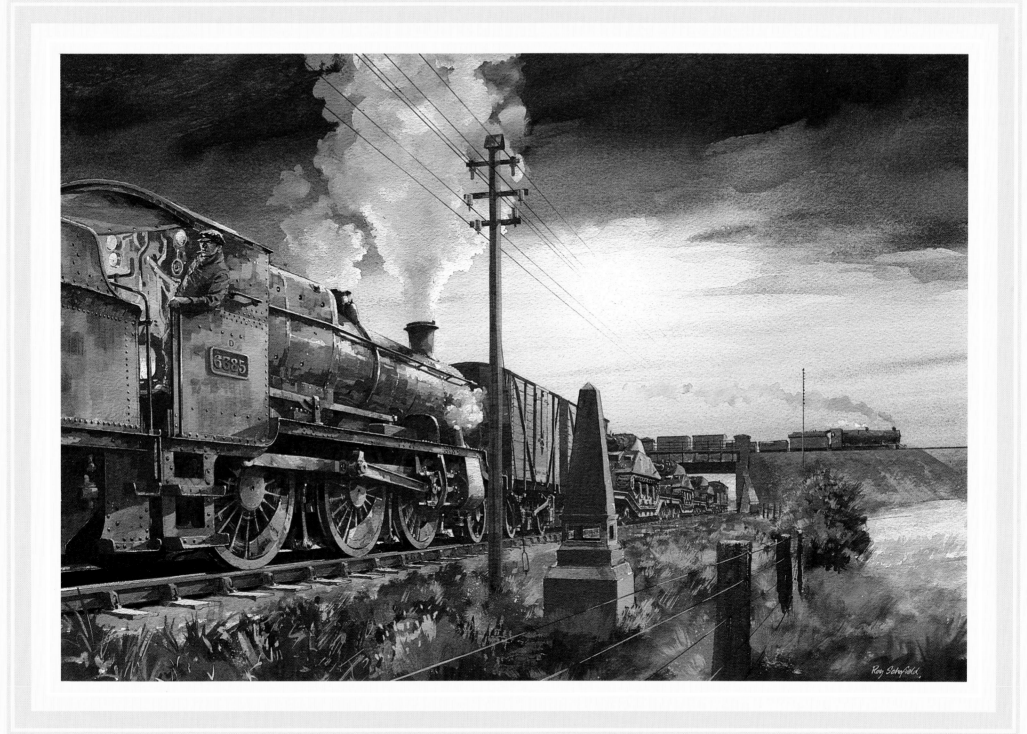

45 *WARTIME GOODS* · *R.SCHOFIELD*

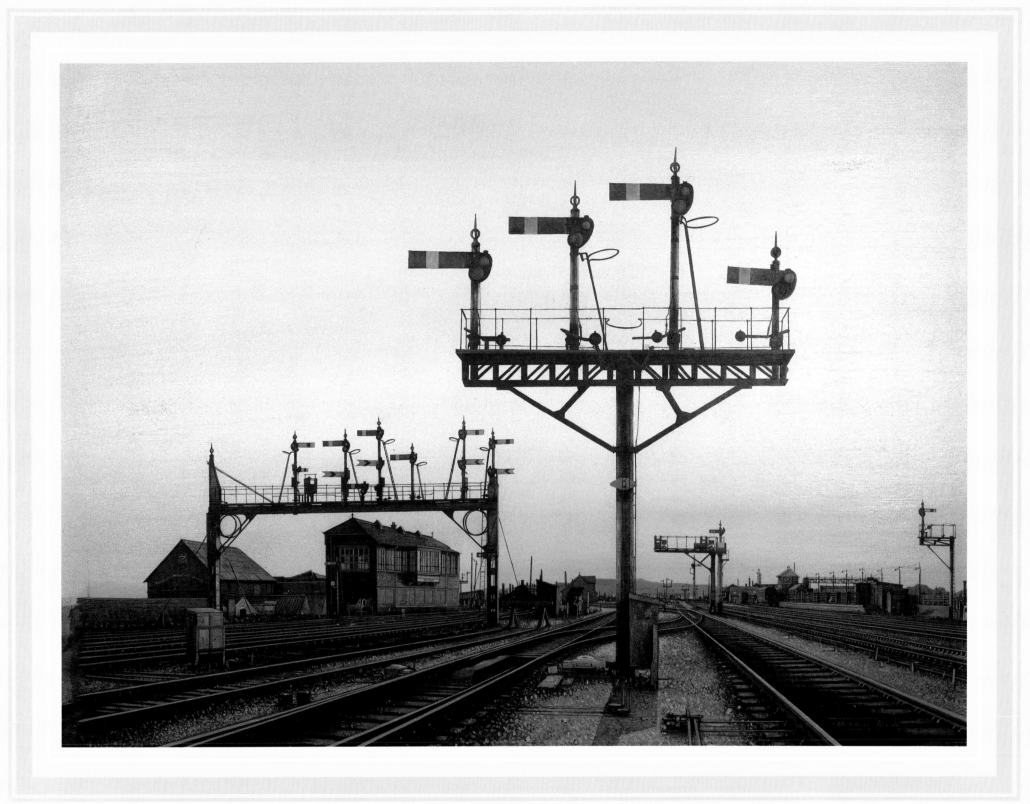

46 *READING WEST – THE EVOCATIVE SILENCE OF AN AUGUST EVENING · L.ROCHE* GRA

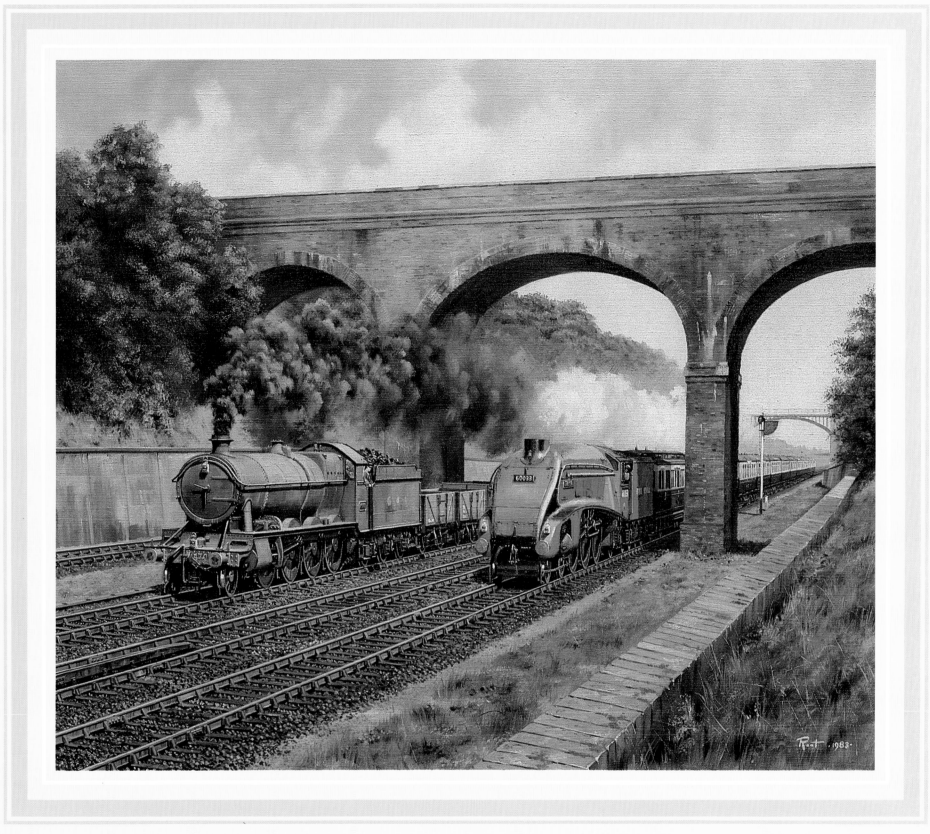

47 *LOCOMOTIVE EXCHANGES, 1948* · *M.T.ROOT* GRA

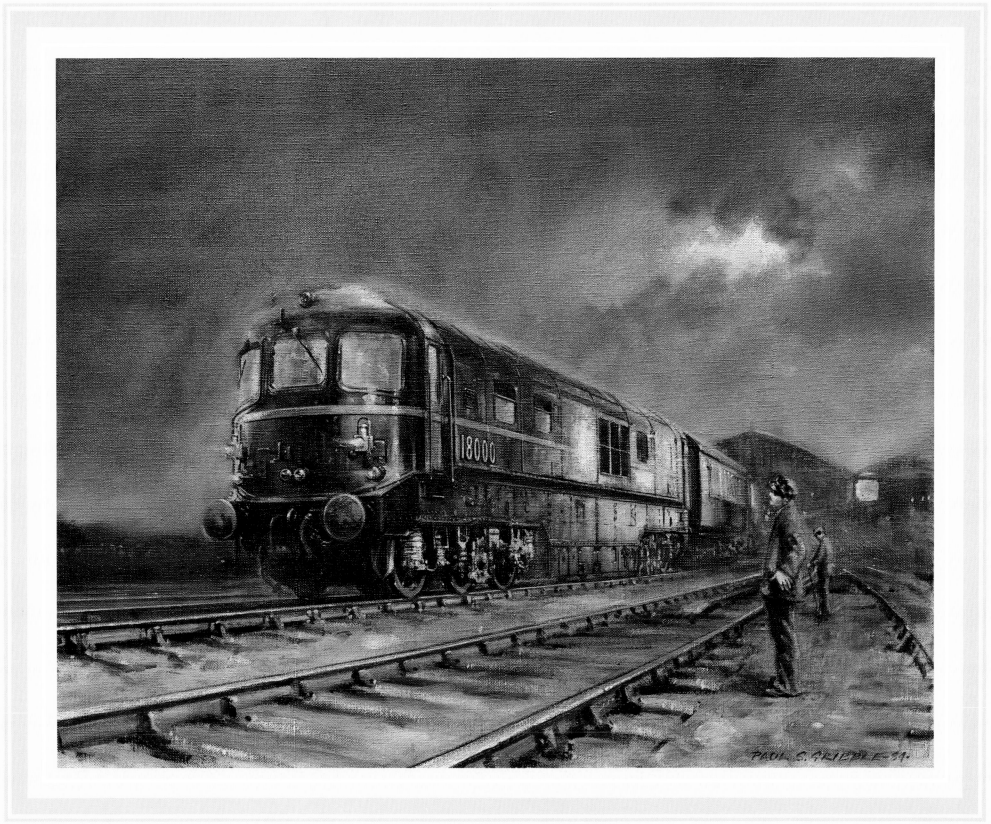

48 *GAS TURBINE* · P.S.GRIBBLE GRA

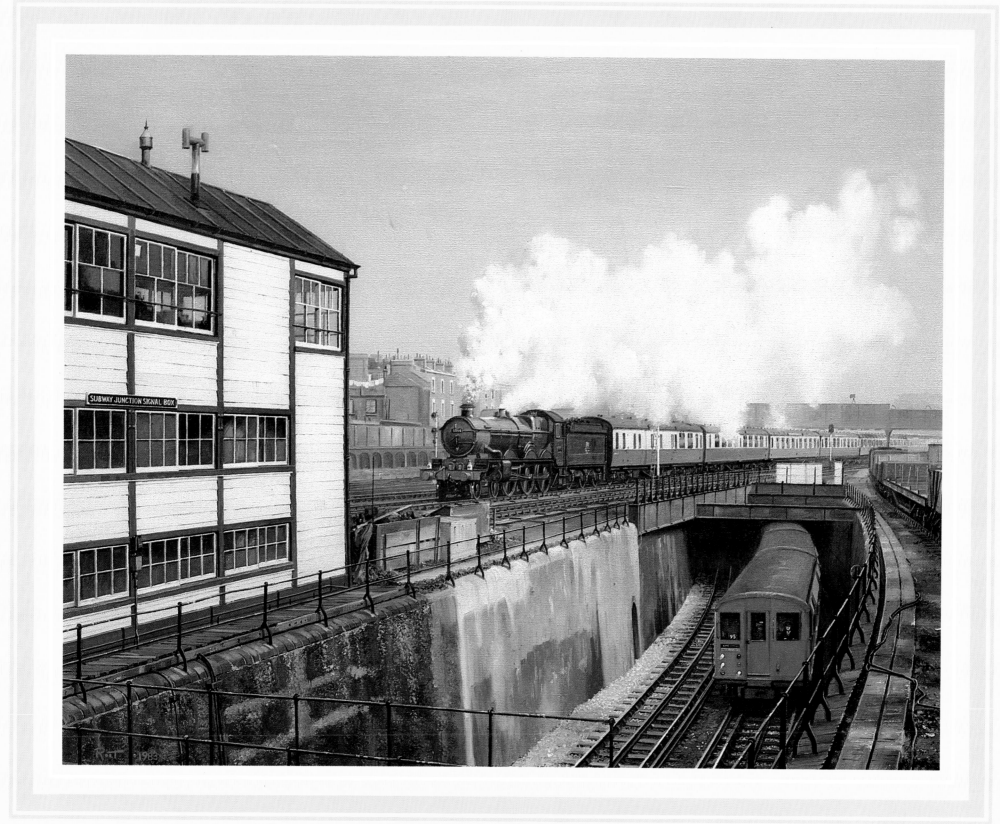

49 *SUBWAY JUNCTION* · *M.T.ROOT* GRA

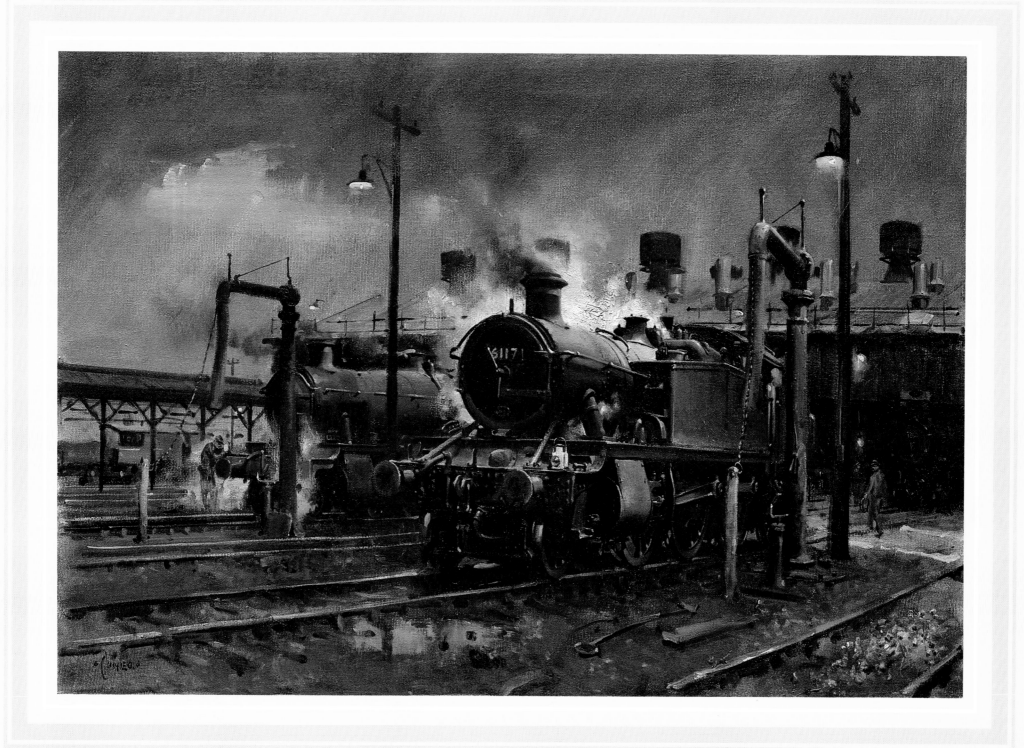

50 STORM ON THE SHED – SOUTHALL · T.CUNEO FGRA

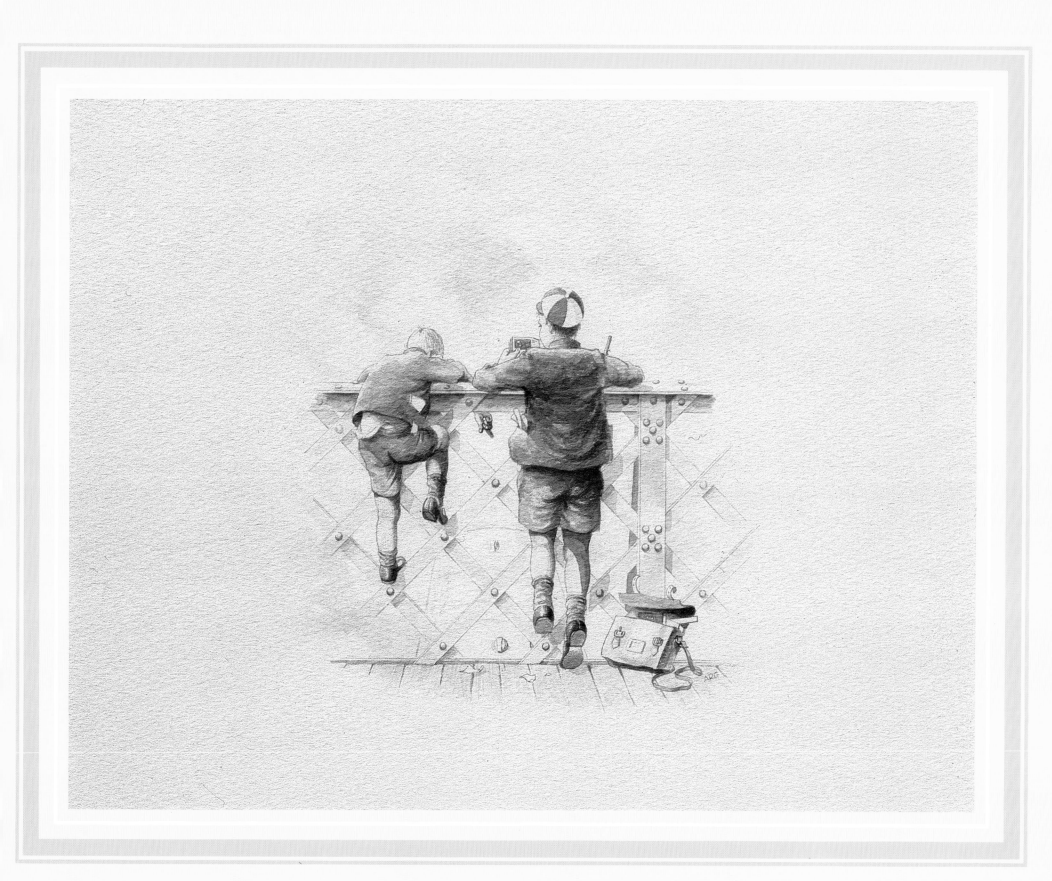

51 *TRAIN SPOTTERS · A.GUNSTON*

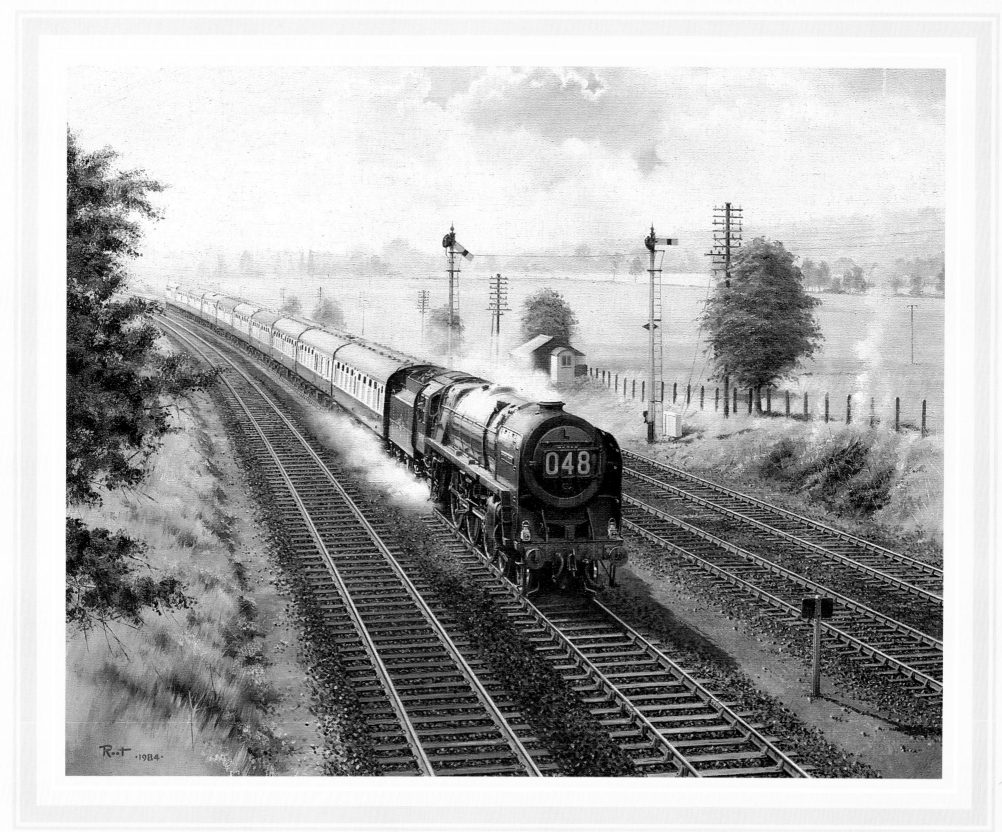

52 RISING STAR · M.T.ROOT GRA

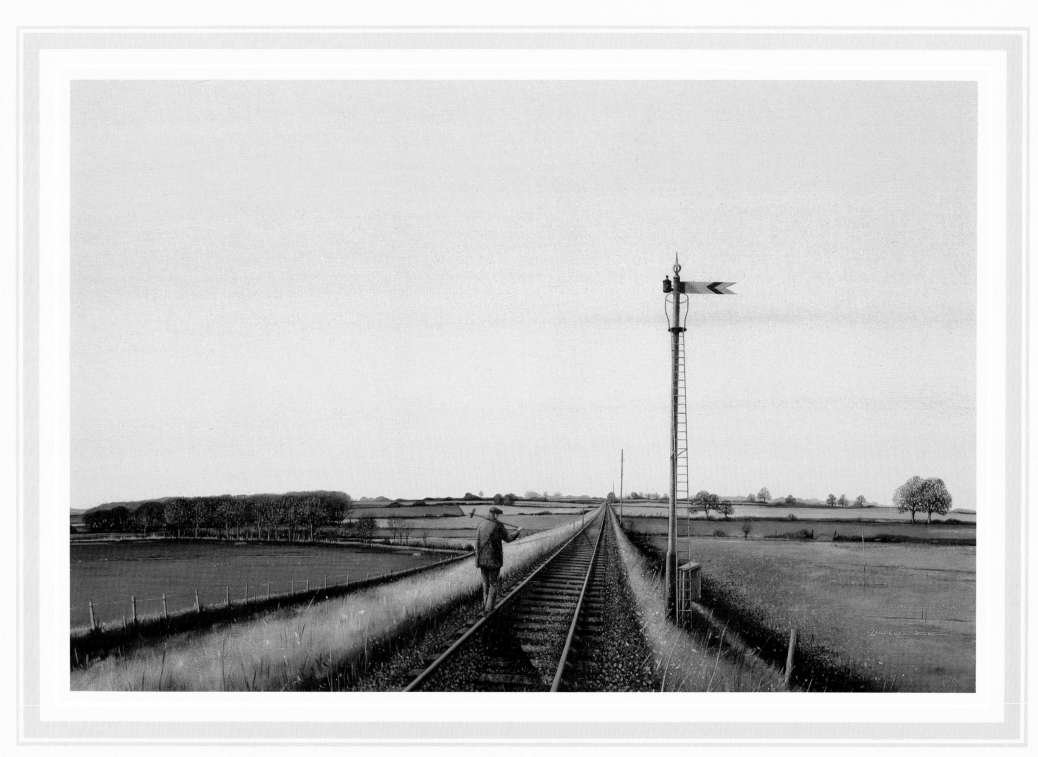

53 *WALKING THE LINE – UFFINGTON/FARINGDON BRANCH · L.ROCHE* GRA

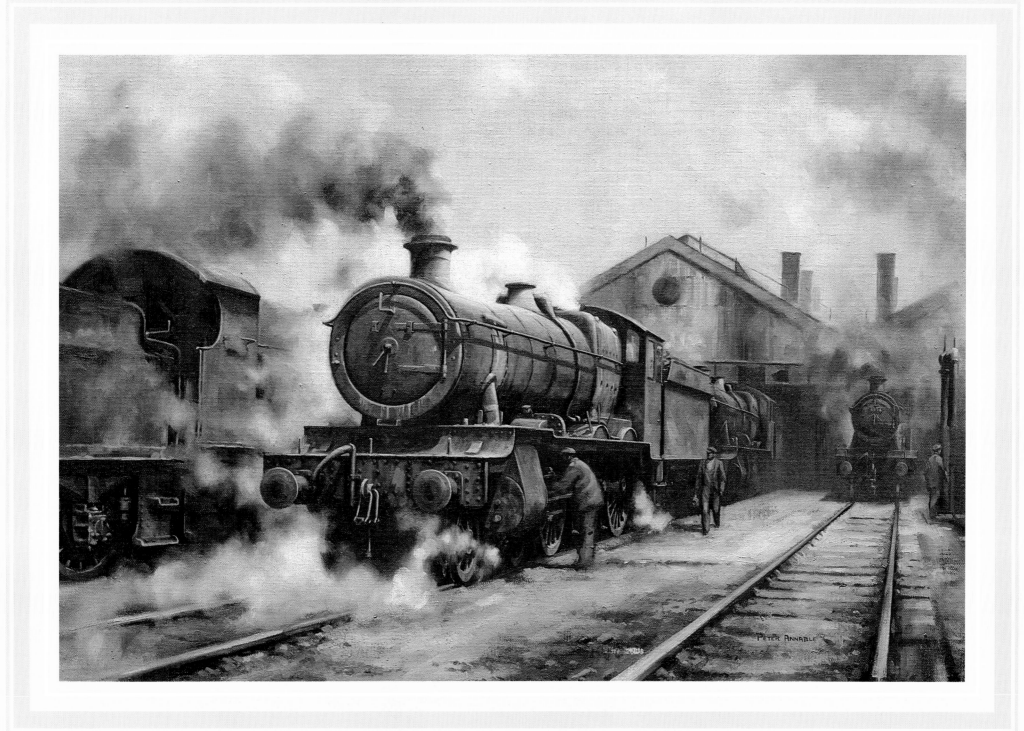

54 DEMISE OF STEAM · P. ANNABLE GRA

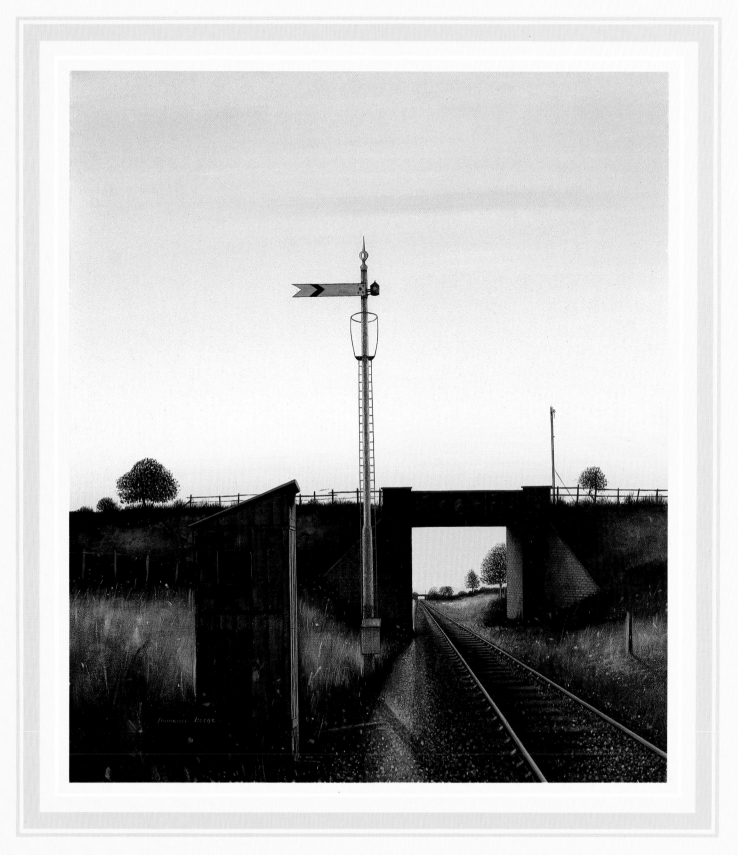

55 SUNDAY MORNING – HENLEY BRANCH · L.ROCHE GRA

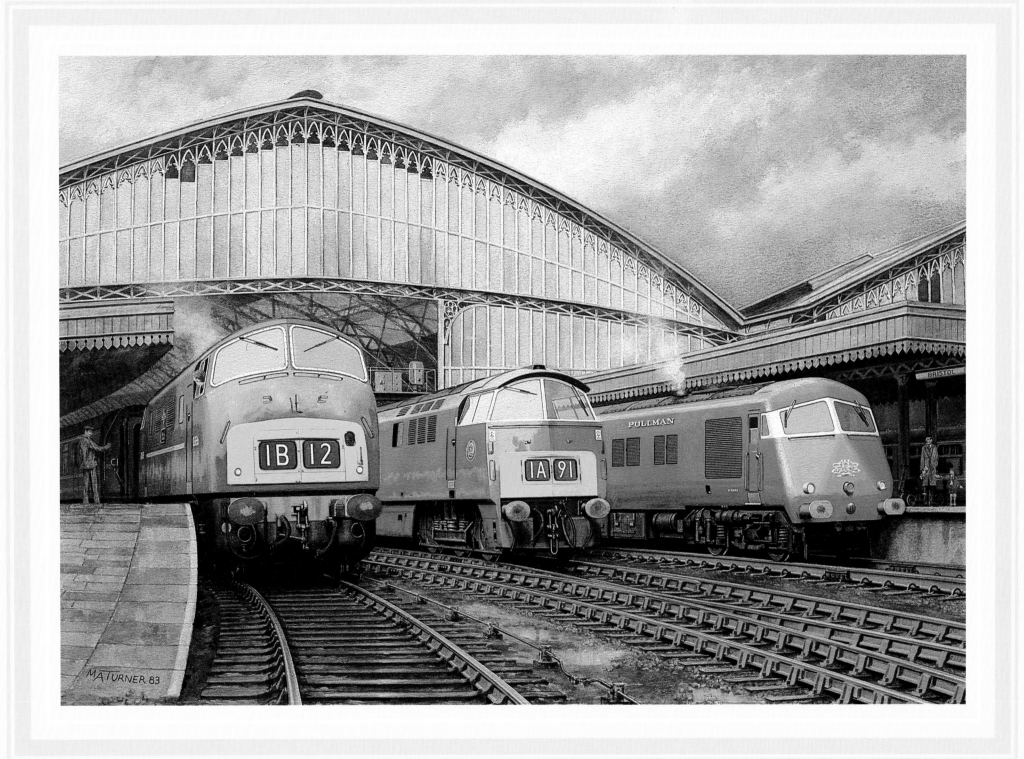

56 *THE NEW IMAGE TAKES OVER AT BRISTOL TEMPLE MEADS* · *M.A.TURNER* GRA

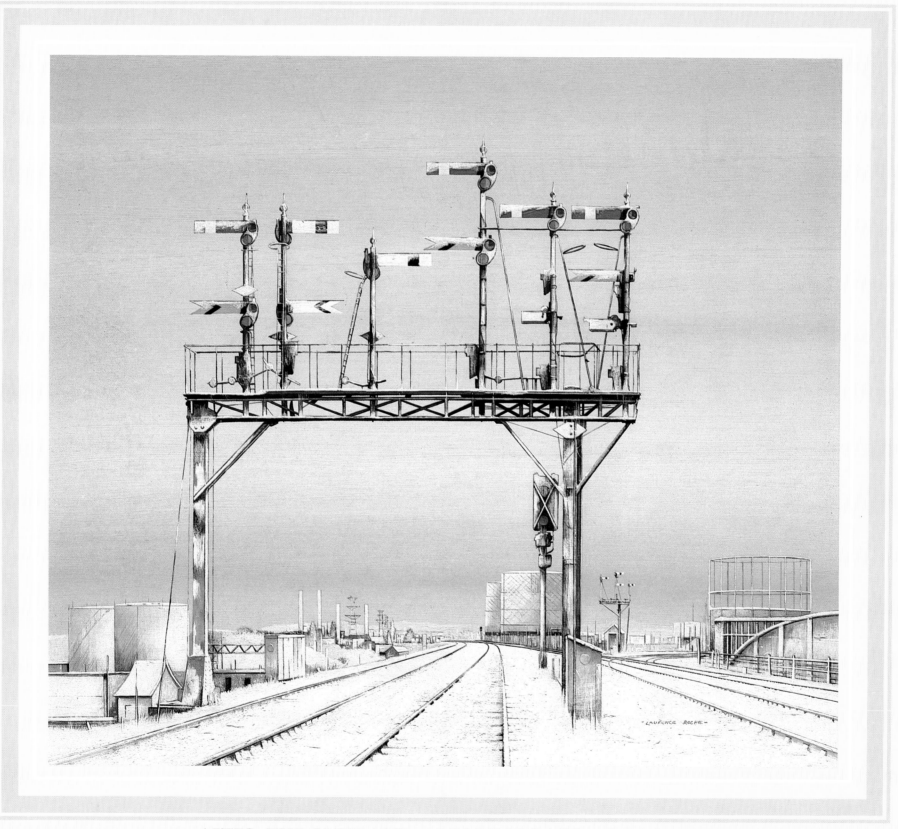

57 *AFTER THE BLIZZARD – READING EAST · L.ROCHE* GRA

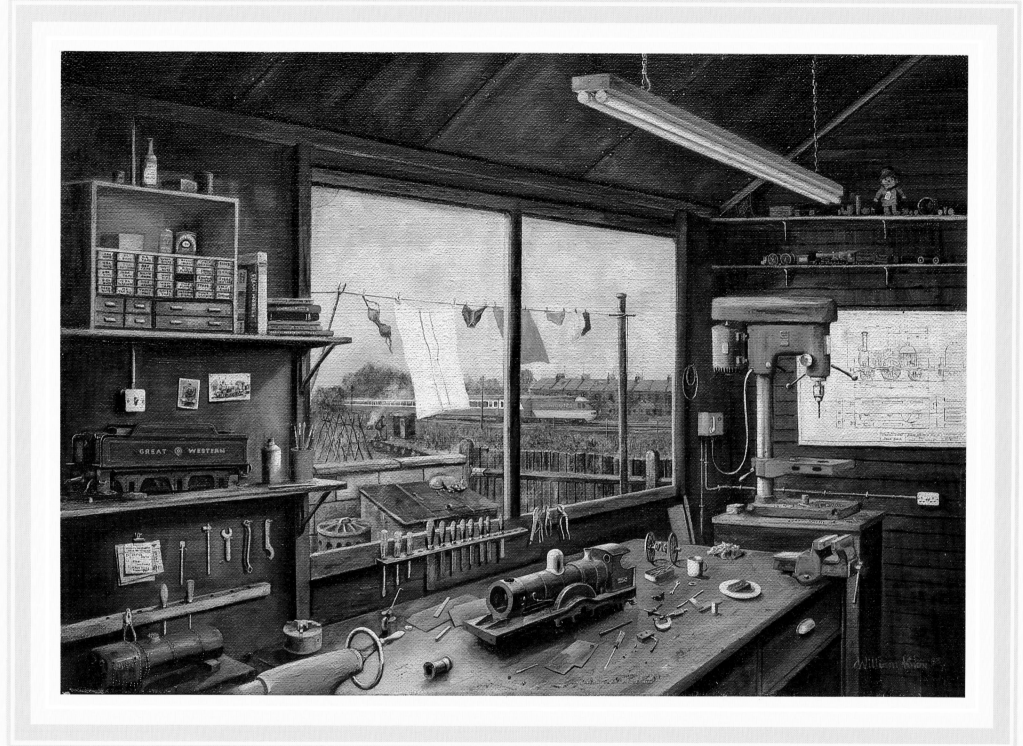

58 *TODAY'S YESTERDAYS · W.KNOX*

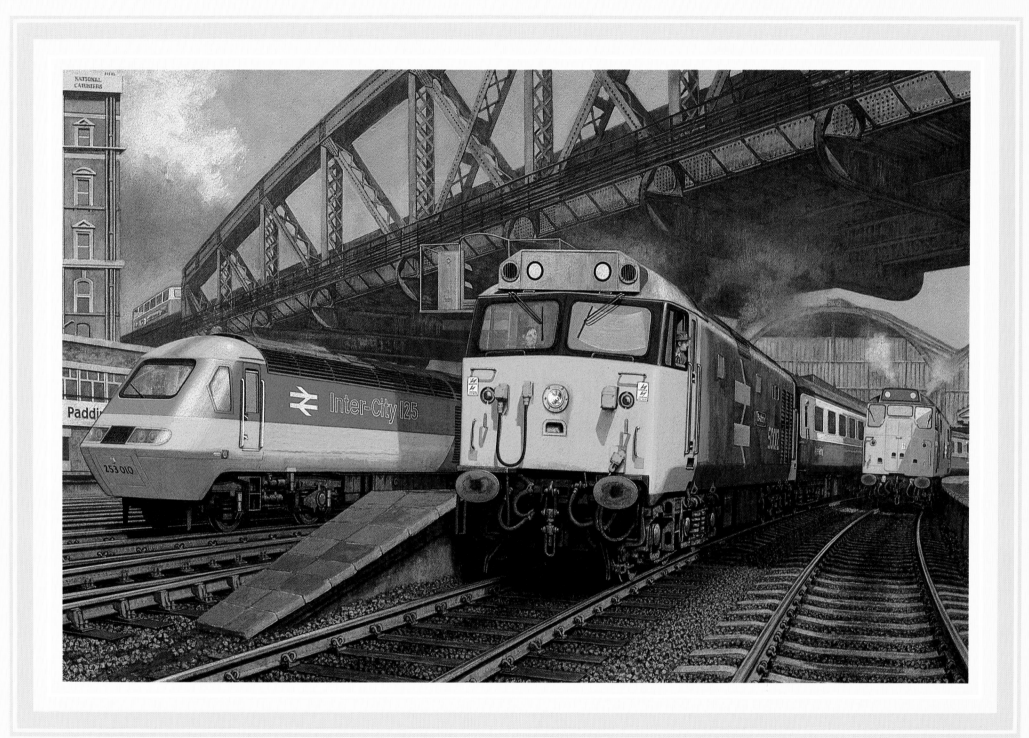

59 PADDINGTON – THE INTER CITY AGE · M.A.TURNER GRA

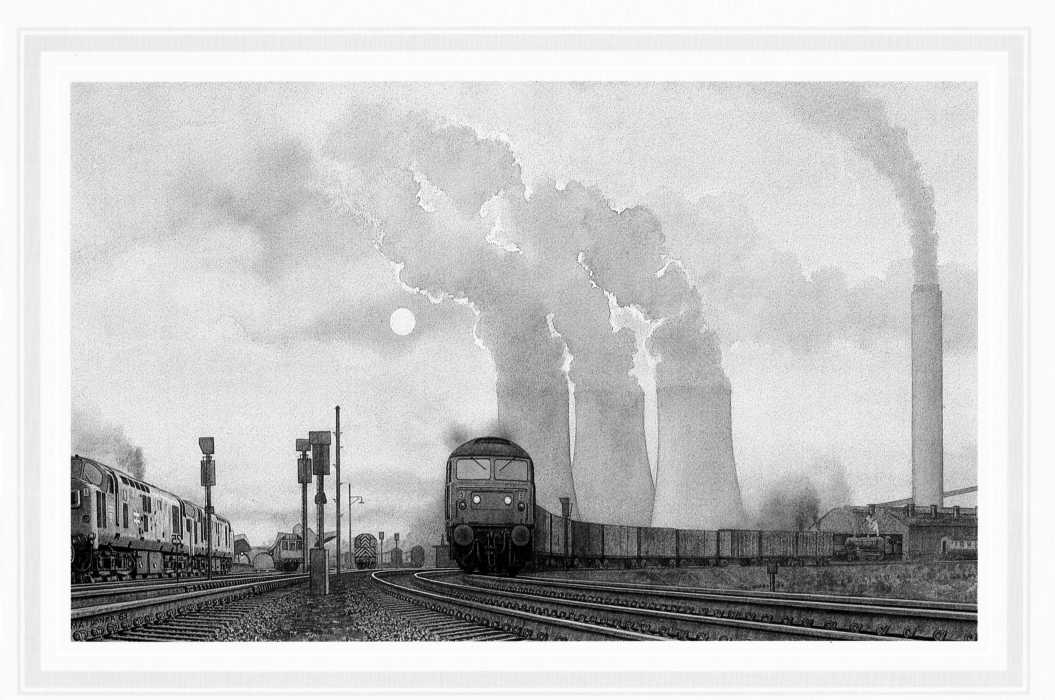

60 *STEAM RETURNS TO DIDCOT* · *M.A.TURNER* GRA

1 *POST COACH – BOX TUNNEL* A. Fearnley, GRA

The dawn of the railway age and horse power versus steam power at the west end of Box Tunnel. Some 60 years after the introduction of the Bristol to London post coach service its days were numbered as a result of the Great Western Railway taking this lucrative business.

2 *ISAMBARD KINGDOM BRUNEL* J. E. Wigston, GRA

I. K. Brunel, Civil Engineer of the Great Western Railway from 1833 to 1859, pictured here in his latter days, framed by the ill fated Atmospheric Railway (South Devon Railway) and his lasting memorials – the Royal Albert Bridge, Saltash (Cornwall Railway), and Box Tunnel (Great Western Railway).

3 *'THE GREAT WESTERN' PADDLE STEAMER* J. E. Wigston, GRA

A majestic combination of steam and sail – an integral part of the plan for the conveyance of passengers from London to New York via Bristol.

4 *THE ROYAL ROAD* P. O. Jones, GRA

Royal patronage by Queen Victoria was granted to the Great Western Railway by her journey from Slough to Paddington on 13 June 1842. The painting shows Her Majesty arriving at Paddington on the first of many Royal journeys on the line throughout her reign.

5 *GANYMEDE AT TWYFORD* D. G. Lewis

Broad gauge locomotive *Ganymede* at Twyford – the small junction station for the Henley-on-Thames branch.

6 *TEMPLE GATE, BRISTOL* B. J. Walding, GRA

The frontage of the railway's Bristol Station in 1867. The grandiose Tudor facade was chosen as being a most suitable frontage to Brunel's original terminus.

7 *THE BREAKERS YARD* A. L. Hammonds, GRA

The breakers yard at Swindon at the end of the broad gauge era in 1892. Through the findings of the Gauge Commission the 4 foot 8½ inch gauge was to become the standard gauge for railways – the Great Western Railway having to convert and re-equip to comply with that ruling.

8 *COPPER AND BRASS, RED AND GREEN* P. D. Hawkins, GRA

A Dean 2-4-0 '22XX Class' locomotive built in 1881/2. A fairly typical example of the motive power used on secondary train services in the late Victorian period.

9 *'LA FRANCE' circa 1905* P. S. Gribble, GRA

No. 102, *La France*, the French built de Glehn compound 4-4-2 locomotive at Bristol Temple Meads – an early Churchward experiment heralding the re-birth of the Great Western Railway.

10 *SUBWAY JUNCTION* D. G. Lewis

Albion – 'Saint' Class No. 2971, one of Churchward's early standard designs, which had a significant influence on locomotive development throughout the world, heads a down express through Subway Junction. *Albion* is passing No.27 of the Metropolitan Railway with a Hammersmith train.

11 *THE GREAT BEAR* P. Annable, GRA

The first British Pacific locomotive built in 1907 and designed by G. J. Churchward. The engine was rebuilt as a 'Castle' Class 4-6-0 locomotive in 1924.

12 *SLOUGH STATION FORECOURT, 1908* E. Bottomley

An impression of the station forecourt showing the Great Western Railway Omnibus Services, an early pioneering diversification of the railway offering the public an integrated transport system.

13 *NOVEMBER EVENING, SOUTHALL, circa 1912* P. O. Jones, GRA

Intensive commuter services were already established in the years prior to the First World War with the steam railmotor taking the brunt of this work.

14 *GOD BLESS OUR LADS* P. O. Jones, GRA

An evocative scene set in a station cafeteria on the Great Western during the period of the First World War.

15 *INDUSTRIAL RELATIONS – GREAT WESTERN* J. E. Wigston, GRA

A tribute to the Trade Unions serving the employees of the Great Western Railway. The portraits are of men who were employed by the railway and served in high office in their respective unions:

Top Charles Perry – Founder of ASLEF.

Centre right John Bromley – General Secretary of ASLEF 1914–1931.

Centre left F. W. Evans – General Secretary, Amalgamated Society of Railway Servants, 1874–1883. (Dismissed from the Railway for belonging to a Union.)

Bottom left J. H. Thomas, PC, MP. – General Secretary, NUR 1916–1931.

Bottom right F. L. Tonge – Member of the Executive of the Railway Clerks Association.

16 *HOLIDAY CROWDS AT PADDINGTON IN THE LATE 1920s* A. Fearnley, GRA

Thanks to publicity by the Great Western Railway and to the greatly improved services, the Cornish Riviera, Glorious Devon and Smiling Somerset were now within easy reach of the metropolis.

17 *THE TESTING PLANT, SWINDON* A. L. Hammonds, GRA

A Mogul locomotive on the engine testing plant at Swindon Works in the early 1920s.

18 *CONVERSATION PIECE – OLD OAK COMMON* A. P. Harris, GRA

The largest engine sheds on the Great Western, at Old Oak Common, in the mid 1920s, a 'County' 4-4-0 being turned, flanked by a 'Saint' and a 'Star'.

19 *BRANCH LINE STEAM* A. Gunston

The 'Bunk' at Cholsey and Moulsford Station in 1929. A Wallingford train sits in the bay whilst passengers await the main line service.

20 *MAIDENHEAD BRIDGE 1925/30* P. Annable, GRA

A view of Brunel's masterly bridge carrying the railway over the River Thames. The flat arches were of a revolutionary design at the time of construction.

29 *SLIP* S. C. Hine
The Great Western Railway was an extensive user of the slip coach which enabled the running of 'non stop' expresses whilst still serving the intermediate stations.

30 *GOOD MORNING DEAR* Mrs M. S. Murray-Whatley, GRA
The sleeping coach ensured comfort and a good night's sleep during overnight journeys on the railway.

31 *WAITER* Mrs M. S. Murray-Whatley, GRA
Fresh trout and salmon were always the travellers fare of this period.

32 *RAILS IN THE SKY* S. C. Hine
The ultimate development of the Great Western Railway's integrated transport system – the Westland *Wessex* which inaugurated the Railway Air Services is shown flying over Bristol Temple Meads.

33 *VALE OF THE WHITE HORSE* P. Annable, GRA
Gleaming copper and brass, chocolate and cream, blends in with the landscape of the Vale minimising the railway's intrusion into pastoral England.

34 *AFTER HEATH ROBINSON* R. E. James-Robertson
In respectful commemoration of W. Heath Robinson's book of cartoons published at the time of the 100th Anniversary of the Great Western Railway.

35 *SWINDON RAILWAY VILLAGE circa 1935* G. P. M. Green, GRA
The heart of the Great Western empire.

36 *TYPICAL WORKMAN'S HOUSE, SWINDON* G. P. M. Green, GRA

37 *ST MARK'S CHURCH, SWINDON* G. P. M. Green, GRA

38 *THE CRICKETER'S ARMS AND THE BAKER'S ARMS, SWINDON*
G. P. M. Green, GRA

39 *THE MECHANIC'S INSTITUTE, SWINDON (Before the fire)* G. P. M. Green, GRA

40 *WHARNCLIFFE VIADUCT* J. W. Petrie, GRA

The zenith of the Great Western – a 'King' Class locomotive, with Centenary Stock on the pre-war *Bristolian*, inaugurated in the company's Centenary Year in 1935, slides in full majesty over the massive Wharncliffe Viaduct.

41 *SUBURBAN SHUTTLE* S. C. Hine

The Great Western Railway were leaders in the development of the diesel powered train – one of the company's distinctive units is here portrayed at a wayside halt.

42 *MOVING DAY* N. Elford, GRA

Household effects and even complete farms were removed by the Great Western Railway's road services.

43 *SURE FOOTED* J. W. Petrie, GRA

Even the unglamorous everyday work of the railway could be spectacular – one of Churchward's '28xx Class', getting to grips with an eastbound freight as it passes Swindon Works in heavy rain.

44 *EVACUEES LEAVE PADDINGTON, circa 1940* Mrs M. S. Murray-Whatley, GRA
The Railway's contribution to the War Effort cannot be understated.

45 *WARTIME GOODS* R. Schofield

The Staines Branch, depicted in this painting, provided a vital link for the conveyance of armaments to the South Coast. Wartime proved to be the Great Western Railway's last and greatest hour of public service under private ownership.

46 *THE EVOCATIVE SILENCE OF AN AUGUST EVENING – READING WEST*
L. Roche, GRA
Sunset on the Great Western leading to the dawn of the new era and nationalisation.

47 *LOCOMOTIVE EXCHANGES, 1948* M. T. Root, GRA
London North Eastern Railway 'Class A4' *Seagull* in Sonning Cutting during the locomotive exchanges of 1948 – after the trials the 'Old Guard of the Great Western' continued triumphantly.

48 *GAS TURBINE* P. S. Gribble, GRA

The new power looms forward – development of alternative power sources had already begun by the late 1940s, the aim being to bring the railways into the 20th century.

49 *SUBWAY JUNCTION* M. T. Root, GRA

The epitomy of British Railways Western Region steam is shown here at this always busy section of line leading from Paddington to the West. (*Based on a photograph by R. C. Riley.*)

50 *STORM ON THE SHED* T. Cuneo, FGRA

An atmospheric scene at the busy Southall Sheds with a '61xx Class' Prairie Tank to the fore.

51 *TRAIN SPOTTERS* A. Gunston
Days Past! – Days Remembered?

52 *RISING STAR* M. T. Root, GRA

The Great Western locomotive classes gradually gave way to the new British Railways Standard Designs in the late 1950s. 'Britannia' Pacific No. 70027 *Rising Star* is seen here, near Pangbourne, on a Swansea to Paddington express.

53 *WALKING THE LINE – UFFINGTON/FARRINGDON BRANCH* L. Roche, GRA

Many of the smaller feeder routes to the main line closed in the pre-Beeching era – the gangers job could be a lonely one; but devotion to duty never waned, even at the end.

54 *DEMISE OF STEAM* P. Annable, GRA

The last majestic days of Great Western Steam – with leaking valves and missing name and number plates apart, the locomotives held their pride even until the day of execution.

55 *SUNDAY MORNING – HENLEY BRANCH* L. Roche, GRA

The new dawn – the branch, now singled, was to live into the technological age

although the passengers that once thronged the platforms at Henley during 'Regatta Week' were to seek alternative transport.